FROM THE FILMS OF

Harry Potter

HOMEMADE

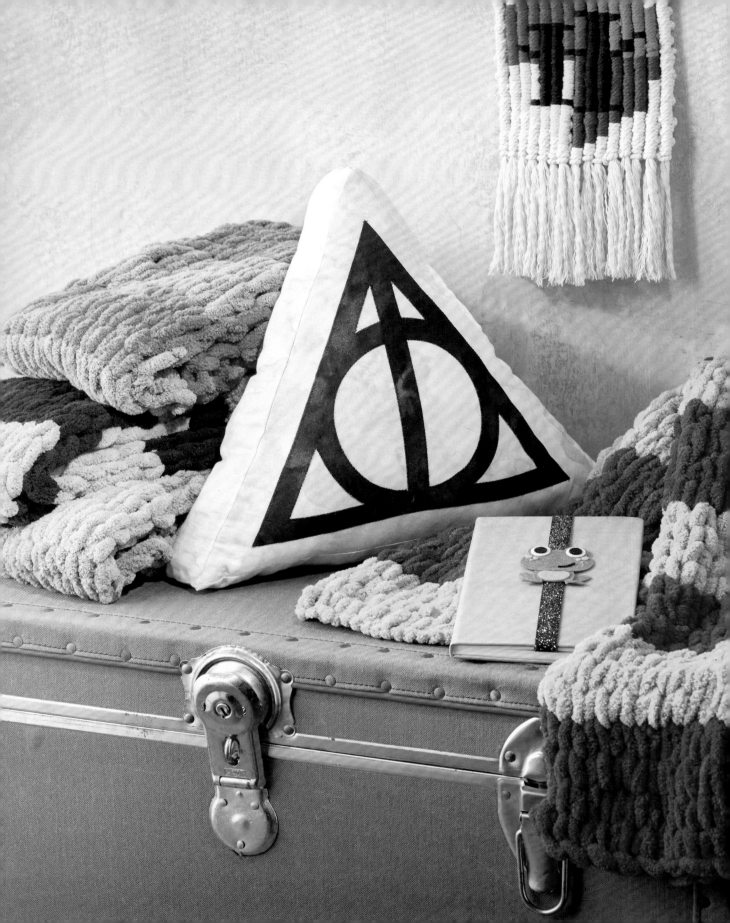

FROM THE FILMS OF

Harry Potter

HOMEMADE

AN OFFICIAL BOOK OF ENCHANTING CRAFTS, ACTIVITIES, AND RECIPES FOR EVERY SEASON

Lindsay Gilbert

INSIGHT
EDITIONS

SAN RAFAEL · LOS ANGELES · LONDON

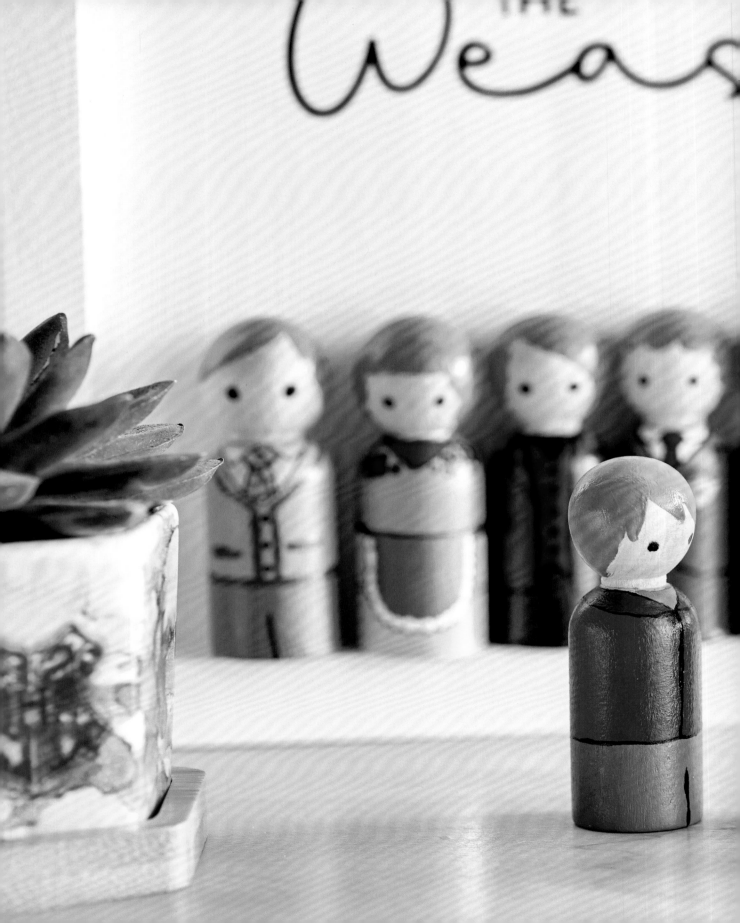

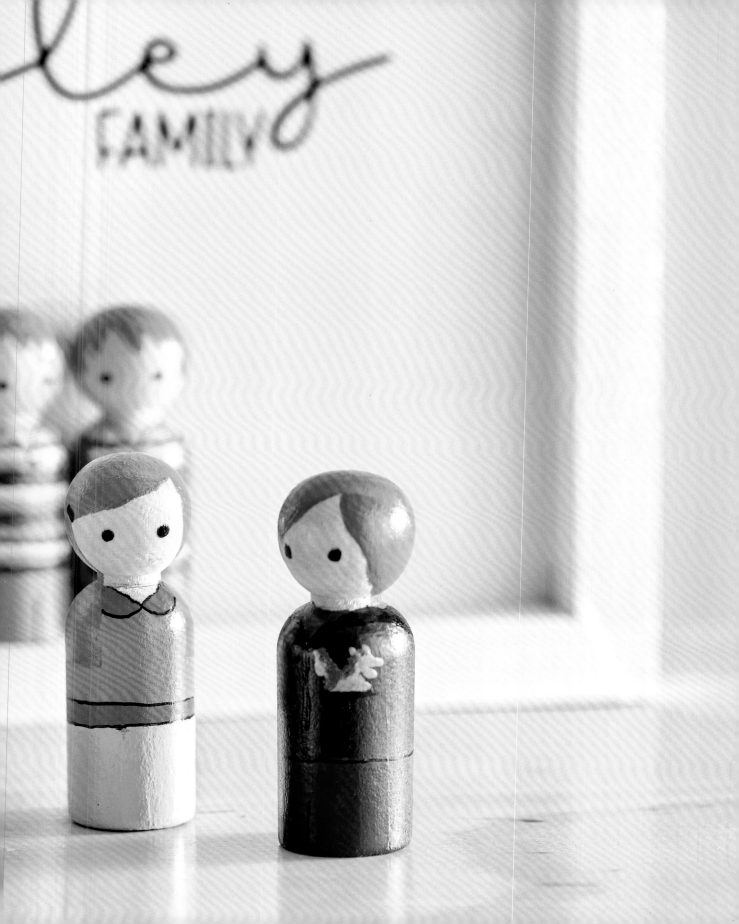

Contents

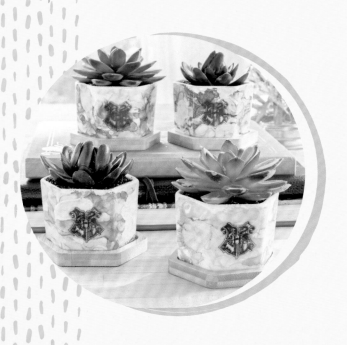

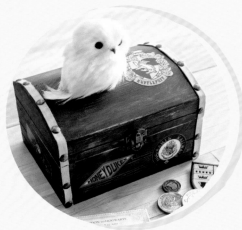

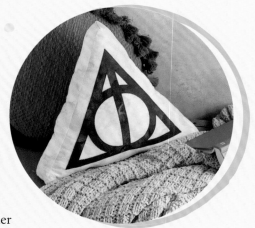

Introduction

To fans around the world, the Harry Potter films are so much more than a plot line, or entertainment to pass the time; they provide an experience of being fully immersed in a spellbinding world of adventure and magic. The Harry Potter films are a work of art with a captivating story that filmgoers come back to over and over again, where anything is possible, and is a story of the power of friendship, love, and overcoming hardships that everyone can relate to. Characters like Harry, Ron, Hermione, Luna, and Neville feel like old friends, taking the audience on adventures alongside them to win against the darkness of Voldemort.

Most importantly, no matter how many times you may have seen the movies, Hogwarts genuinely feels like home. As soon as the doors to the Great Hall open, there is a sense of nostalgia, almost like we've lived in this alternate universe all along. Can you imagine sitting at those long tables, enjoying feasts year after year, walking the halls and grounds, and relaxing in the Gryffindor common room? Hogwarts might be a fictional school, but that doesn't mean we can't make our homes *feel* like we're living there, right?

Crafters are constantly thinking about how to bring the world of Harry Potter to life in our homes. Inspired by the magical Harry Potter films, this official book of homemade Harry Potter crafts and recipes to help you bring that magical cozy feeling of the Wizarding World into your own home all year long.

Each section of this charming craft book is filled with creative, handmade projects to add coziness to your home, no matter the season. Display both your house pride and favorite plants with Hogwarts House Planters (page 25), customize a Hogwarts Trunk Trinket Box (page 65) like you're ready to go back to Hogwarts, hang a Two-Tiered Magical Chandelier (page 89) to fill the room with a glowing autumn ambiance, make winter a little warmer with handmade Hogwarts No-Sew House Scarves (page 135), and so much more!

And what's the fun of crafting without making some delicious snacks and drinks along the way? Each seasonal chapter also contains a pair of

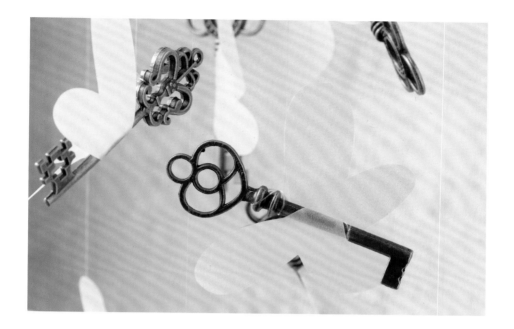

Harry Potter–inspired recipes to bring some magic into the kitchen. From a refreshing summertime Marauder's Mixed Berry Lemonade (page 47) to Hagrid's comforting Treacle Toffee (page 121) in winter, there's something for everyone!

Inside the book, you'll find detailed instructions to guide crafters of every skill level through each of the projects and recipes with success, and you may learn new techniques along the way. As an extra bit of magic, you'll also find interesting behind-the-scenes trivia, film stills, and concept art alongside the projects to provide an inside look at the epic adventure that was the making of the Harry Potter films.

The most difficult task will be to decide which project to begin with, whether it's creating a Weasley Sweater Cup Cozy (page 139) for the entire family, or whipping up a batch of First Task Truffles (page 17) to enjoy during a Harry Potter movie marathon. No matter where you start, the most important thing is to have fun. Grab your glue gun and find your most comfortable crafting spot with a cozy, warm drink (Slughorn's Caramel Apple Warmer (page 81), perhaps?), and get ready for some Harry Potter homemade magic! And as a bonus, each template from this book is also available online at www.insighteditions.com/harrypotterhomemade to download to recreate your favorite craft over and over again. Happy creating!

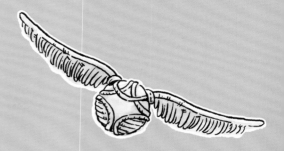

Chapter 1

· ·

Spring

"A spring afternoon I discovered a bowl on my desk, just
a few inches of clear water in it. Floating on the surface
was a flower petal . . . as I watched, it sank . . . just before
it reached the bottom, it was transformed, into a wee fish.
It was beautiful magic, wondrous to behold."

Horace Slughorn, *Harry Potter and the Half-Blood Prince*

Professor Sprout's Greenhouse Concoction

Professor Sprout teaches Herbology, which means she spends a lot of her time tending to the plants in the Hogwarts' greenhouses, and always encourages students, especially Neville Longbottom, to "grow" their love of Herbology. In the films, Pomona Sprout's costume was specially designed with multiple snails crawling on it because she is always working outdoors.

In *Harry Potter and the Chamber of Secrets,* Professor Sprout teaches her second-year students how to repot Mandrakes. A Mandrake's cries can be fatal, so the students are instructed to wear earmuffs as protection. The root of the Mandragora, or the magical Mandrake plant, has powerful restorative properties that can be used as an antidote to revive those who have been Petrified.

Warmer spring weather is the time for growth, especially for many fruits and vegetables. I would imagine that Professor Sprout would be delighted to harvest an enchanting spring bounty grown in Hogwarts' very own greenhouses to share with students and staff. What better way to use your own collection of produce than with this refreshing Greenhouse Concoction inspired by our favorite Herbology professor?

What you'll need

MAKES 1 DRINK

- 1 green apple, peeled and cored
- ⅓ cup (79 ml) frozen pineapple
- ¼ cup (59 ml) banana
- 1 cup (237 ml) fresh or frozen spinach
- 2 tablespoons (30 ml) lemon juice
- ¼ cup (59 ml) milk
- 1 tablespoon (15 ml) honey

Instructions

1. Add all the ingredients into a blender.

2. Blend until smooth.

3. Pour into a glass and enjoy the "fruits" of your labor!

Behind the Magic

Creatures created for the films, like Mandrakes, start off as drawings or concept art (see concept sketch on page 14). They then progress to maquettes, or small sculptures, so that you can see what the creature will look like and how they can physically be built. Next, molds are made of the creatures so then they can be replicated using foam latex or silicone. Another team is all about making repairs, painting, and adding details to the creatures. Fifty pots containing animatronic Mandrakes were created for the film. One of these moving Mandrakes even bit Draco Malfoy's finger!

"Welcome to Greenhouse Three, second years.
Now gather round everyone.
Today, we're going to repot Mandrakes!"

—Pomona Sprout, *Harry Potter and the Chamber of Secrets*

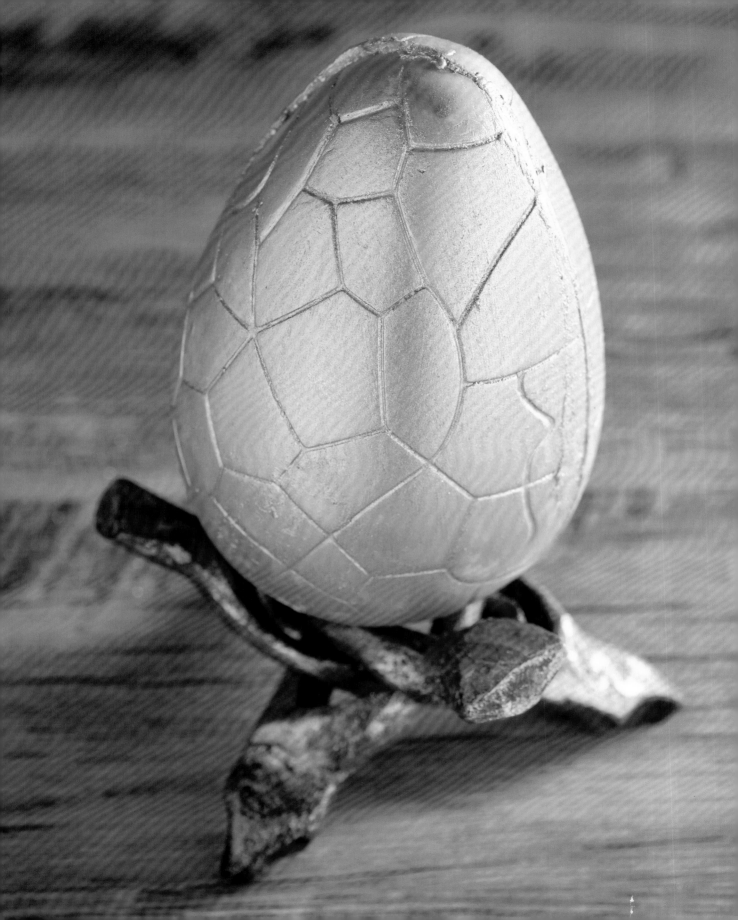

First Task Truffles

In *Harry Potter and the Goblet of Fire*, Harry's name mysteriously came out of the Goblet of Fire as the fourth champion to compete in the Triwizard Tournament. Even though there was a spell to prevent it from happening, many believed that Harry somehow put his own name into the goblet. For the first task in the tournament, Harry, only being in his fourth year at Hogwarts, was required to retrieve a golden egg that was being guarded by a Hungarian Horntail, one of the fiercest dragons.

These first task truffles aren't guarded by dragons, but they do have a surprise inside! No, not a clue for the next task, but a decadent lemon cookie crunch truffle. Lemon is a wonderfully delicious spring flavor, and this truffle is truly magical. Like finding the prized golden chocolate Easter egg on a sunny spring afternoon, you can relive the excitement of the first task of the Triwizard Tournament with this sweet dragon egg treat!

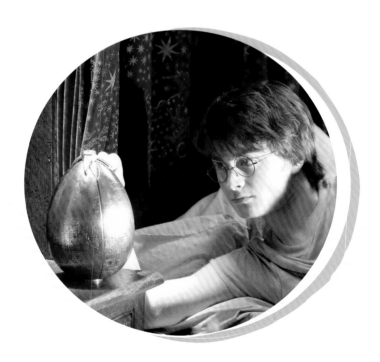

What you'll need

MAKES 2 DRAGON EGGS

- 6 ounces (170 g) white chocolate chips
- Yellow gel food coloring
- 4.1-by-2.7-inch (10.414-by-6.858 cm) dragon egg mold (can be found online)
- 15-20 lemon sandwich cookies (14.3 oz/405 g)
- 4 ounces (113 g) cream cheese
- Gold food color spray
- Food-safe paint brush
- Metallic gold food powder

Instructions

1. Place the white chocolate chips in a microwave-safe bowl or use a double boiler to melt the chocolate. If using the microwave, heat the chocolate in 30-second increments, stir, and repeat until the chocolate is completely melted.

2. Add in a small drop of yellow gel food coloring. Stir until evenly incorporated.

3. Use the back of a spoon or a pastry brush to apply a thin, even layer of chocolate to each side of the egg mold. Place in the refrigerator for 10 to 15 minutes for the chocolate to set.

4. Put the lemon sandwich cookies into a plastic bag and use a rolling pin to crush them into small or medium pieces.

5. Pour the cookie pieces into a mixing bowl and add in the cream cheese. Mix the two together until evenly combined.

6. Carefully remove the chocolate eggs from the molds.

7. Fill each egg half with the cookie mixture.

8. Warm up a frying pan on low heat. Hold one half of the egg down on the pan to slightly melt the edges. Press the two halves together immediately to stick them together. Use your finger to smooth the seam.

9. Spray a coat of gold food color spray over the outside of the egg to give it a golden shimmer. Let the coloring dry completely. For extra sparkle, use a paint brush to cover the egg with metallic gold food powder.

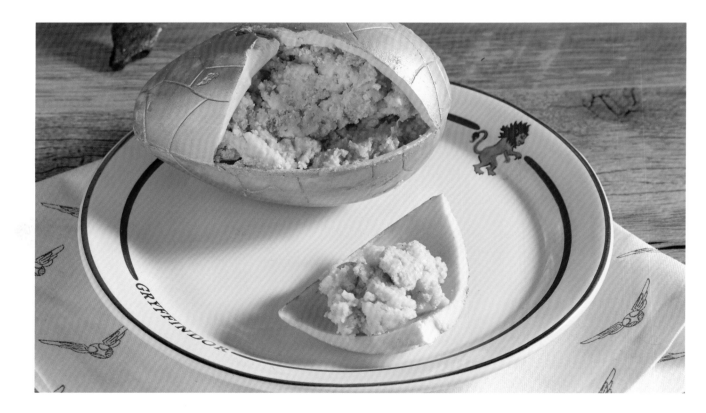

Behind the Magic

Unfortunately, live dragons weren't available for the filming of the first task of the Triwizard Tournament. Instead, Harry and the tournament spectators had to be very accurate with what they were looking at so they could add in the movie magic of a CG dragon later. Filmmakers gave the actors a target of a blue tennis ball on the end of a scaffolding pole, which was swung around in the passes and sweeps that the dragon was supposed to make.

A maquette, or 3D model, of the Hungarian Horntail was made with working flapping wings and a removable tail. The wingspan of the model was more than 14 feet, about the same length as a minivan! By using photos and measurements of this model, animators and artists could render the CG dragon using computers. The whole process of creating the Hungarian Horntail you see in the film involved at least 50 people and took more than a year.

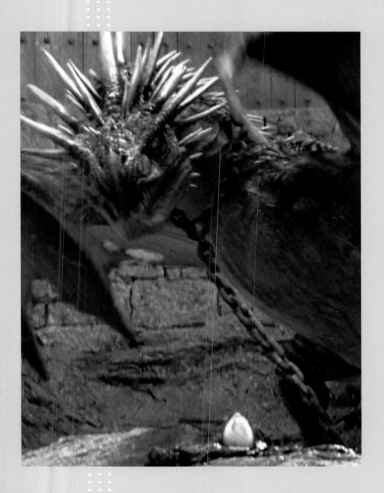

"Dragons? That's the first task? You're joking!"

"Come on, Harry. They're seriously misunderstood creatures. Although, I have to admit, that Horntail is a right nasty piece of work."

Harry and Hagrid, *Harry Potter and the Goblet of Fire*

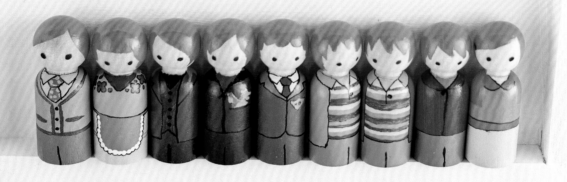

THE Weasley FAMILY

envelopes

pens & pencils

Weasley Family Peg Doll Portrait

Families like the Weasleys are loving and generous, and all around well-respected in the wizarding community. They enjoy spending time together and even took a family holiday to Egypt! Most importantly, they immediately welcomed Harry into their family and loved him like one of their own.

Arthur won a prize of seven hundred Galleons from a contest in the *Daily Prophet*. He and Molly decided to spend most of the gold on a month-long summer holiday with the family to visit Egypt to see their son, Bill, who was working there for Gringotts Wizarding Bank. Their family photo from the trip, which is referenced in this craft, was featured in the *Daily Prophet* with the announcement of their winnings!

This Weasley Family Peg Doll Family Portrait is a fun project that allows you to change out the backgrounds to transport the Weasleys to Egypt or The Burrow. Not only can you make peg dolls to represent the Weasley family, but maybe this project will inspire you to make a peg doll portrait of your next family vacation!

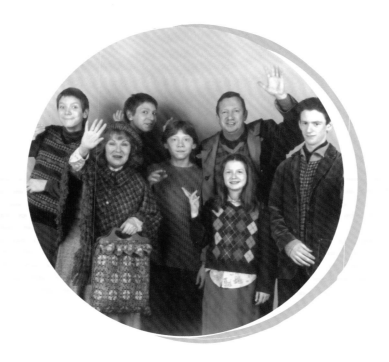

What you'll need

- 8.5-by-5.3-inch (21.59-by-13.462 cm) wood canvas
- Acrylic paint, white plus various colors for peg doll details
- Mechanical pencil
- 7 wood peg dolls
- Detail paint brushes
- Thin-point permanent marker, in black
- Clear spray paint or varnish
- Egypt and The Burrow templates, pages 153–154

Instructions

1. Turn the wood canvas upside-down so that it looks like a frame. Paint the sides and inside of the canvas with a few coats of white acrylic paint. Set it aside to dry.

2. Use a mechanical pencil to lightly draw the hair, clothing, and any unique character features on the wooden peg dolls.

3. Add color to the peg dolls using the small paint brushes and various colors of acrylic paint. I find it easiest to paint one color on all the peg dolls at once.

4. After the paint has dried, go over the details, including the eyes, with a thin permanent marker.

5. Coat the peg dolls with clear spray paint or varnish to help keep the Weasleys looking their best.

6. Apply the "Weasley" name to the background of the canvas. This can be done by hand or with adhesive vinyl. To change the "locations" of the Weasley family, tear out the Egypt or The Burrow images from the template (pages 153–154) and place behind them.

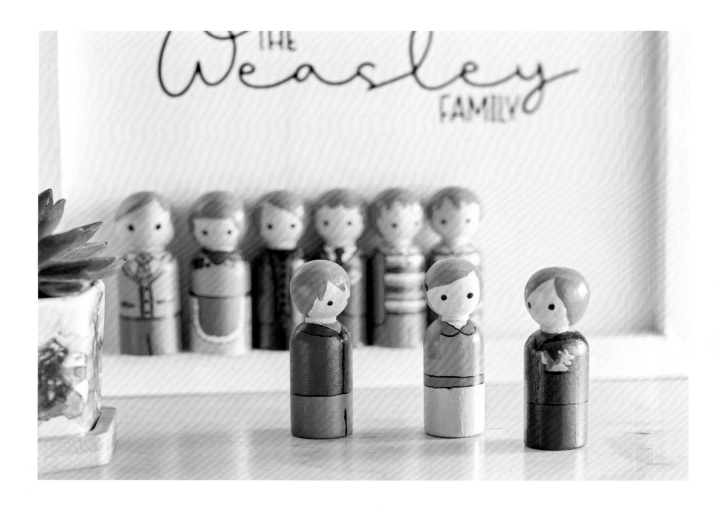

Behind the Magic

When Harry first arrives at The Burrow, we immediately see that Mrs. Weasley has charmed various household items to take care of chores. For example, a dish is washing itself in the sink, a knife is chopping up vegetables, and knitting needles are creating one of the many handmade items Mrs. Weasley is known for. This could have all been done digitally, but it's surprising to know that it was actually a mechanical prop!

"It's not much."
"It think it's . . . brilliant!"

—Ron Weasley and Harry Potter, *Harry Potter and the Chamber of Secrets*

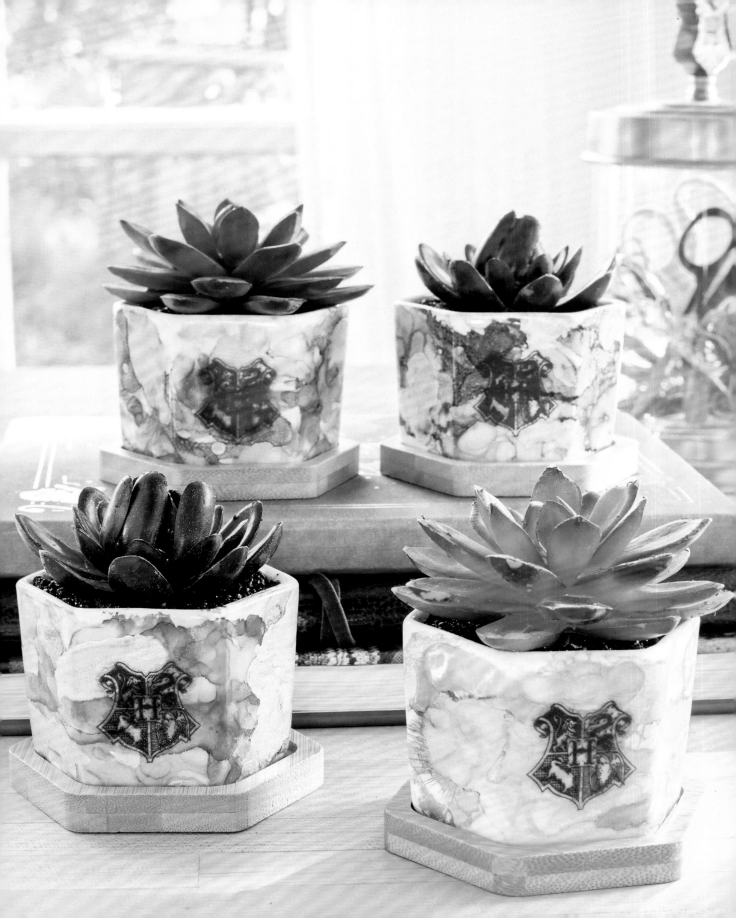

Hogwarts House Planters

Declared by the Sorting Hat during a special ceremony, students are placed into one of the four houses: Gryffindor, Hufflepuff, Ravenclaw, and Slytherin. Each house has their own dormitories, table for dining in the Great Hall, and teams to compete against each other in Quidditch.

Like a true wizard, you can put your house pride on display with a custom planter in the colors of your Hogwarts house. This will be a spellbinding addition to any room, and the perfect home for a herbologist's favorite spring herbs and plants!

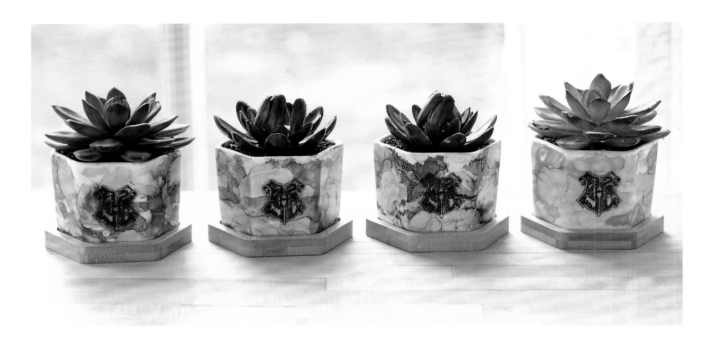

What you'll need

- 4 white ceramic plant pots
- Isopropyl (rubbing) alcohol
- Small spray bottle
- Alcohol inks: red, green, yellow, blue
- Metallic alcohol inks: gold, silver, dark silver
- Straw or compressed air can
- House Crest templates, page 28, or Hogwarts Crest template, page 29 ⊙
- Clear spray paint or varnish
- Black cardstock, adhesive vinyl, or permanent marker
- Succulent plants, real or fake
- Paper towels
- Latex gloves

Instructions

1. Clean the outside of the plant pots well with alcohol.

2. Fill a small spray bottle with alcohol.

3. Choose which Hogwarts house you want your pot to represent:
 - Gryffindor: red and gold ink
 - Ravenclaw: blue and silver ink
 - Hufflepuff: yellow and dark silver ink
 - Slytherin: green and silver ink

4. Hold one plant pot in your hand and spritz it with alcohol. Add one small drop of alcohol ink onto the pot and use the straw or compressed air to gently spread the ink around. It will dry quickly!

5. If you don't like how the pot looks, you can start over by cleaning the pot again with alcohol.

6. Keep adding drops of alcohol ink to the pot and blow the ink around until you get the look you want. For added shimmer, place drops of metallic ink onto the pot.

7. When the ink has dried, spray the pots with clear spray paint or varnish to keep the ink from rubbing off.

8. Trace the House Crest templates (page 28,) or Hogwarts Crest template (page 29) onto a separate piece of paper and cut the design out of black cardstock, adhesive vinyl, or use a marker to apply the crest onto the front of the pot.

9. Place some succulent plants into the pots. If using fake ones, put some floral foam in first and add in some small rocks. If using real succulents, fill the pots with soil and add in the plants.

TIP:

When working with alcohol ink, wear gloves to keep your hands from getting stained and put something down to protect your workspace.

Behind the Magic

Did you know that the four Hogwarts house colors are associated with the four elements? Gryffindor, with colors of red and gold, is connected to fire; Slytherin, green and silver, to water; Hufflepuff, yellow and black, represent earth; and Ravenclaw's blue and bronze are connected to air.

For the films, each house's common room was designed with the specific house color schemes in mind. For example, the Gryffindor common room was decorated in reds and golds with classic oak furniture. The walls of the common room are covered in a digital re-creation of the scarlet-and-gold, fifteenth century tapestry *The Lady and the Unicorn*. For the Slytherin common room, there is no red to be found anywhere. The room is completely green and black and has luxurious black leather sofas.

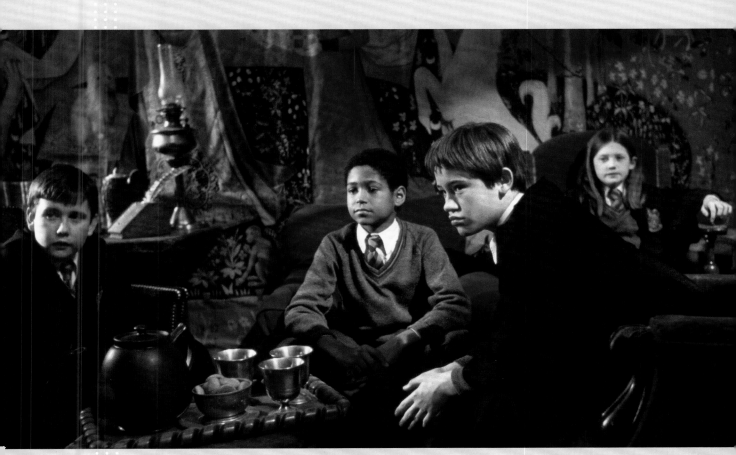

House Crest Templates

Gryffindor

Slytherin

Hufflepuff

Ravenclaw

Hogwarts Crest Template (2 sizes)

TIP:

If you have a bigger pot, download and print the Hogwarts Crest and House templates at your desired sizes at www.insighteditions.com/harrypotterhomemade.

QU
EP TRACK OF A

THAM HOL

Arrows
Castle Bats
Philly Catapults
Dudley Cannons
Falmouth Falcons
Holyhead Harpies
Kenmare Kestrels
Montrose Magpies
Pride of Portree
Puddlemere United
Tutshill Tornados
Wigtown Wanderers
Wimbourne Wasps

Quidditch Pitch Lip Balm

Quidditch is a big deal at Hogwarts! Each house has its own team that plays against each other throughout the course of the school year, and every game is attended by excited students and professors alike. In the spring, one house wins the Quidditch Cup: an enormous, silver trophy cup.

Quidditch players spend hours zooming through the air, and the fans are out there cheering their teams on. When you think about it, wind-chapped lips are a likely scenario when the weather is starting to warm up. Don't you think that every player and Quidditch fan alike would love to have a Quidditch Pitch Lip Balm in their pocket to help keep their lips from getting chapped on the Quidditch Pitch? I know I would.

What you'll need

MAKES 10 QUIDDITCH PITCH LIP BALMS

- 2 tablespoons (30 ml) beeswax pellets
- 2 tablespoons (30 ml) coconut oil
- 2 tablespoons (30 ml) almond oil
- Craft stick
- 10 to 20 drops mint flavoring
- Lip balm sphere containers

Instructions

1. In a microwave-safe bowl, add in the beeswax pellets. Heat the pellets up in 30 to 45 second increments until completely melted.

2. Stir in the coconut oil and almond oil using a craft stick. If the mixture starts to solidify, put it back into the microwave to re-melt it.

3. Add 10 to 20 drops of the mint flavoring to the mixture and stir well.

4. The lip balm sphere containers come with three pieces: base, inner shelf, and the top cover. Prep the container by pressing the inner shelf into the top cover. You should hear it click into place. Set the base piece aside.

5. Carefully pour some of the lip balm mixture through the inner shelf and into the top cover. Fill until it covers the top section of the inner shelf piece.

6. Let the lip balm mixture cool for 5 to 10 minutes, and then twist the base piece onto the top cover.

7. The lip balm needs time to solidify before use. Place the lip balm sphere containers in an undisturbed, room-temperature area to harden overnight or you can put them in the refrigerator for 1 to 2 hours. For best results, store lip balm at room temperature.

TIP:

To make a Golden Snitch Lip Balm, simply use a gold or yellow lip balm sphere container, or paint the lip balm yourself (before adding the lip balm to it) using metallic gold spray paint.

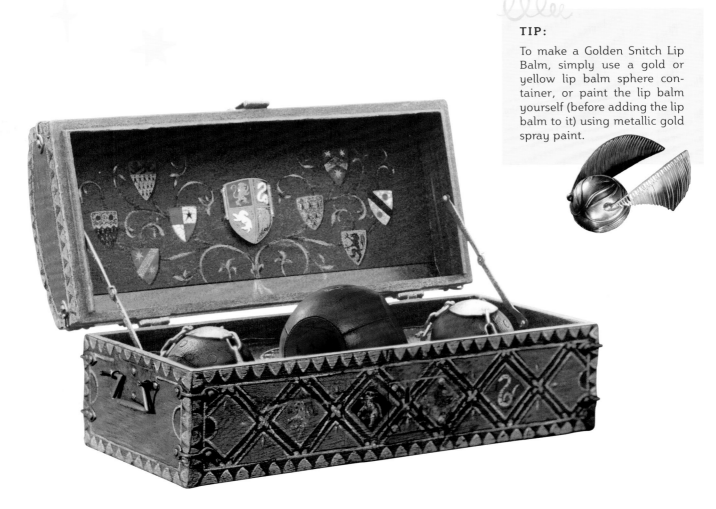

Behind the Magic

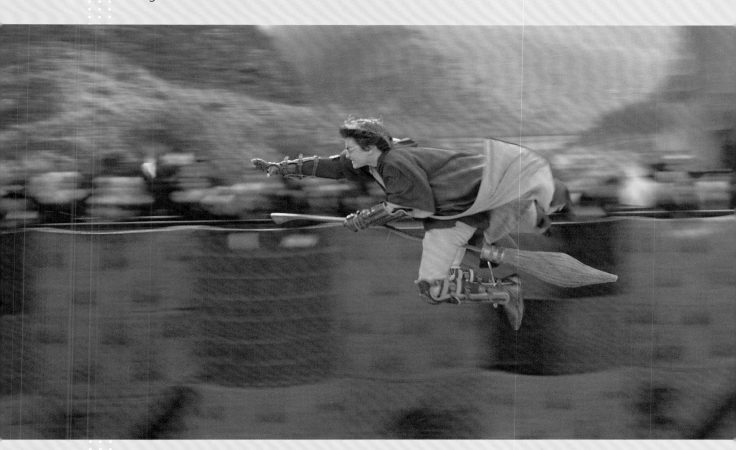

Quidditch looks fun, but flying on a broom isn't as easy as you might think. For the films, broomsticks with a bicycle seat were built onto hydraulic rigs run by computers to make them fly and move around in the air. Most Quidditch scenes are shot against a green screen or blue screen. Only one or two shots were actually made on location for the first Harry Potter film. Tom Felton, the actor who plays Draco Malfoy, said that while "flying" on a broomstick was fun, the seats were actually very uncomfortable.

"Quidditch is easy enough to understand.
Each team has seven players: three Chasers, two Beaters,
one Keeper, and the Seeker . . . that's you."

—Oliver Wood, *Harry Potter and the Sorcerer's Stone*

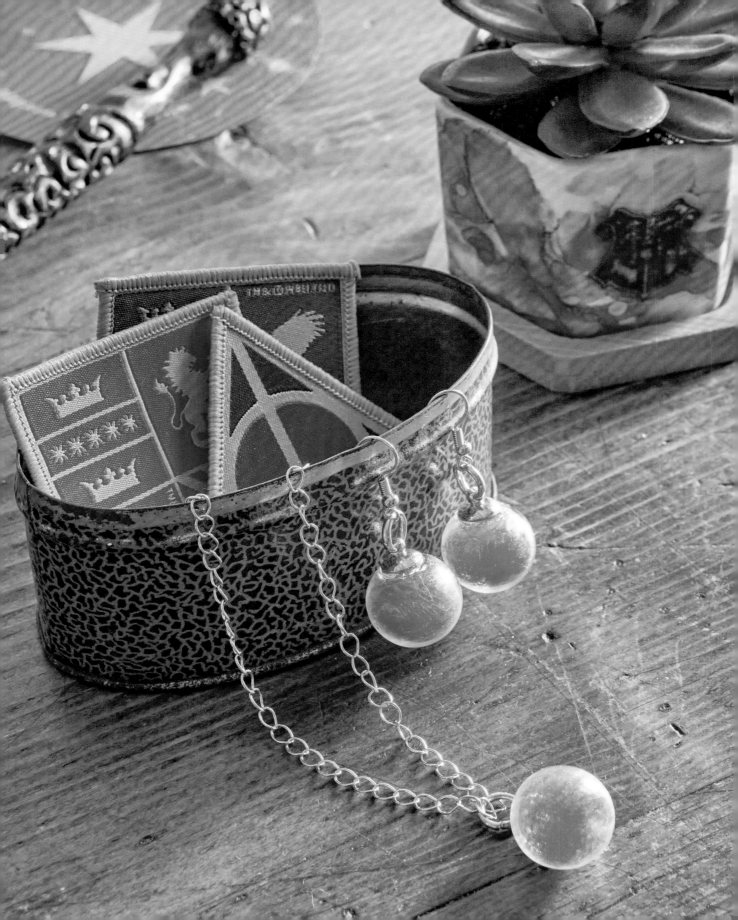

Remembrall Jewelry Charms

In the wizarding world, a Remembrall is a glass ball that fills with swirling red smoke when its owner has forgotten something. When whatever was forgotten is remembered, the ball turns clear.

In *Harry Potter and the Sorcerer's Stone*, Neville Longbottom receives a Remembrall from his gran. It immediately starts glowing red and Neville is bewildered because he can't remember what he had forgotten. When you look closely at the scene, it's possible that Neville may have forgotten to wear his Hogwarts' robes. Everyone else around him is wearing one, and he's only wearing his sweater.

If you're often forgetting things, these Remembrall Jewelry Charms might just be what you need! Maybe they'll help you remember important things that need to get organized when spring cleaning, or maybe they'll help remind you why you walked into the room. The charms are the perfect size to wear as earrings and necklaces, and like the Remembrall was for Neville, these would be a great gift idea.

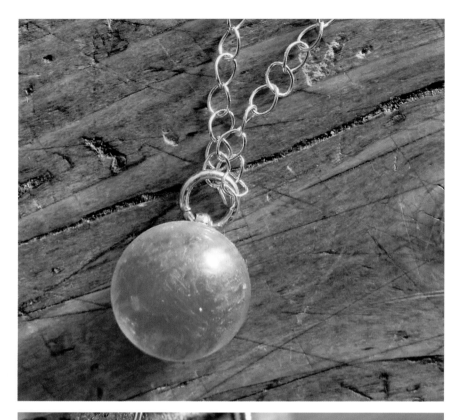

What you'll need

- 2-by-6-inch (5.08-by-15.24 cm) strip of red tulle
- 3 clear glass globe pendants
- Tweezers, optional
- Jewelry adhesive
- 3 jump rings
- Jewelry pliers
- Necklace chain
- 2 earring hooks

Instructions

1. Cut five pieces of red tulle (measuring roughly ¼ inch) for each pendant and set them aside.

2. Carefully place a few pieces of red tulle inside the glass globes. Because the pendants are so small, tweezers can make this step a little easier.

3. Apply a small amount of strong jewelry adhesive to the pendant lid and place the lid over the globe opening. Hold the lid in place until the adhesive is set. Repeat steps 1 through 3 for the other globe pendants.

4. Open the three jump rings using jewelry pliers and hook them through the pendants. Close the jump ring on one pendant, and then thread a necklace chain through it. For earrings, place an earring hook onto the jump ring before closing.

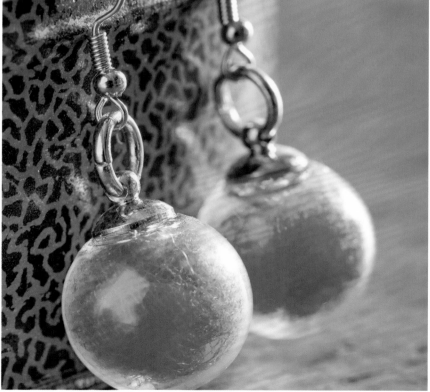

Behind the Magic

Matthew Lewis, the actor who portrays Neville, is a lot like his character in real life. A little shy, and a bit forgetful and clumsy. As Matthew grew older in the films, he lost a lot of his baby fat. To get him to look more like "Neville," he wore a fat suit, false teeth, and even had prosthetics placed to help his ears stick out more. His first day on the set, Matthew was filming the broomstick lesson scene. Needless to say, he was quite surprised to start the Harry Potter experience by being harnessed to a broomstick and flying around like he was on a rollercoaster!

"The only problem is I can't remember what I've forgotten."

—Neville Longbottom, *Harry Potter and the Sorcerer's Stone*

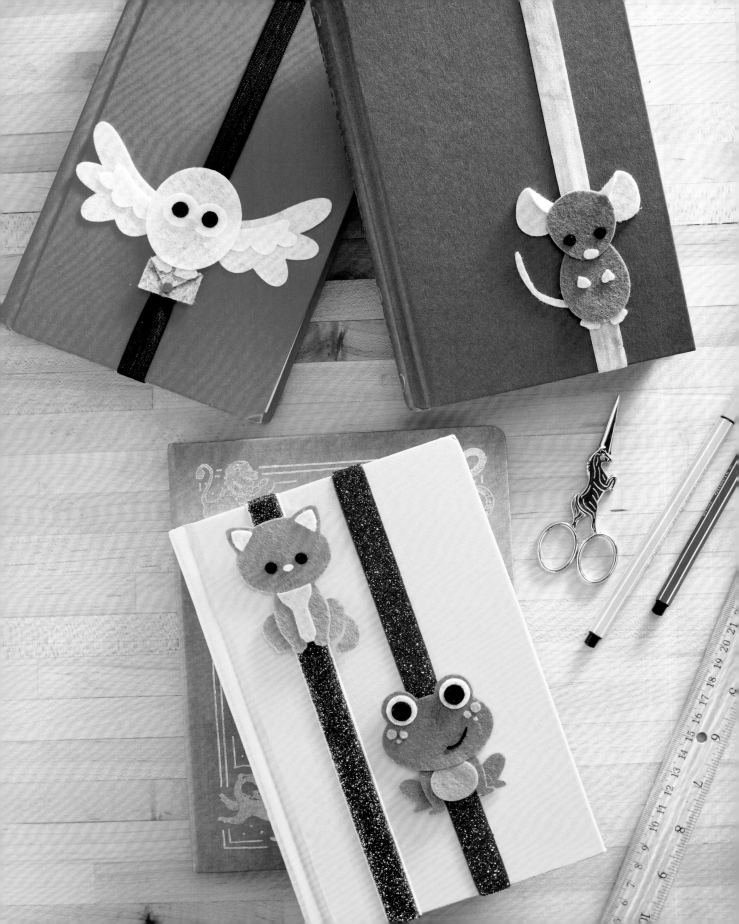

Creature Companion Bookmarks

I n *Harry Potter and the Sorcerer's Stone*, Harry receives his Hogwarts acceptance letter. At the end of the "supply" list, students are invited to bring a pet with them to school. The most notable animal companions are Harry's owl, Hedwig; Hermione's cat, Crookshanks; Ron's rat, Scabbers; and Neville's toad, Trevor.

Hermione is often found reading and studying with Crookshanks by her side, especially at the end of term. For fellow full-time readers, these bookmarks inspired by our favorite animal companions from the films will save your spot while reading through your book list.

What you'll need

- Creature Companion templates, pages 42–43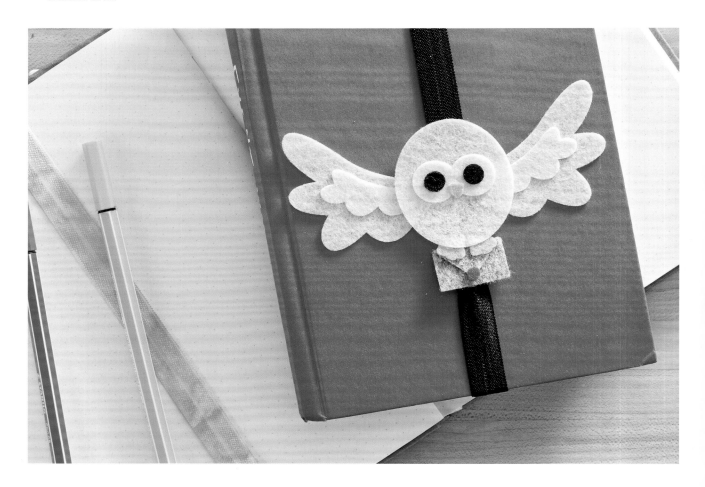
- Felt sheets in various colors
- Scissors
- Fabric glue
- Fold-over elastic
- Needle and embroidery thread, optional

Instructions

1. Trace the Creature Companion templates (pages 42–43) of the bookmark creature(s) you want to make.

2. Use the template pieces to cut felt out in the colors that you want your creature to be.

3. Put the pieces of the creature companion together using fabric glue. For best results, hold the pieces in place until the glue has set before attaching another piece.

4. Alternatively, instead of attaching the smaller pieces using glue, you can hand-sew the details using a needle and embroidery thread.

5. When you are finished assembling the creature(s), let the glue dry completely.

6. Cut a piece of fold-over elastic measuring 14 to 15 inches long.

7. Find the center of the elastic and attach the creature companion to the elastic using fabric glue. Hold in place until the glue has completely dried.

8. Bring the ends of the elastic together to make a circle. Attach the ends with adhesive glue or hand-stitch them together.

TIP:

- If you don't hold the felt pieces in place until the glue sets, the pieces will likely come apart as you are assembling the creature(s).

- Choose any patterns and colors of elastic you'd like to coordinate with your creature companion!

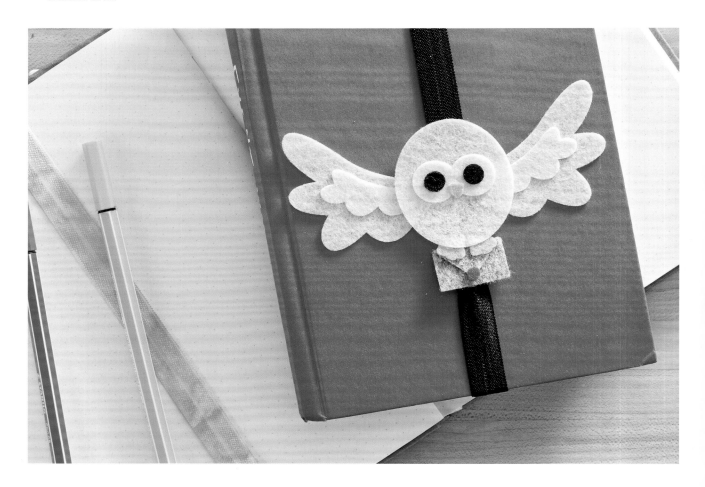

Behind the Magic

All the live animals in the films were well taken care of. In fact, more animals are in the films than you might expect. Seven owls were needed to play Hedwig! These owls were named Gizmo, Oops, Swoops, Oh Oh, Kasper, Elmo, and Bandit. Crookshanks the cat is played by Crackerjack, Prince, and Pumpkin. Scabbers was actually played by twelve live rats, a puppet rat, and a mechanical rat. Four toads played the part of Trevor. And one of the four dogs playing Fang, Hagrid's dog, was adopted by one of the trainers after filming was done.

"I'm warning you, Hermione! Keep that bloody beast of yours away from Scabbers, or I'll turn it into a tea cozy!"

"It's a cat, Ronald! What do you expect? It's in his nature."

"A cat? Is that what they told you? It looks more like a pig with hair if you ask me."

"That's rich! Coming from the owner of that smelly old shoe brush. It's all right, Crookshanks, just ignore the mean little boy."

Ron and Hermione, *Harry Potter and the Prisoner of Azkaban*

Creature Companion Templates

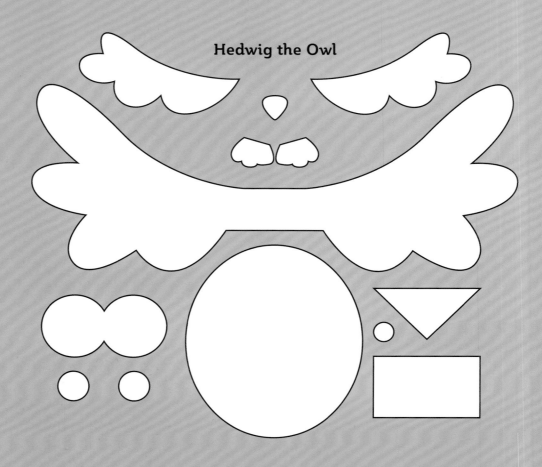

Hedwig the Owl

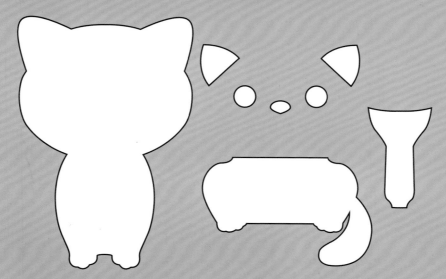

Crookshanks the Cat

Scabbers the Rat

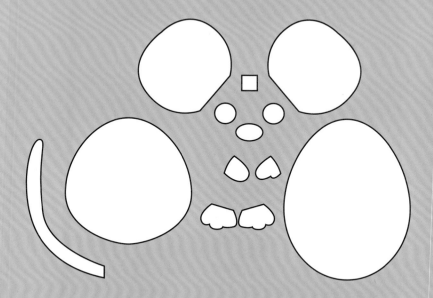

Trevor the Toad

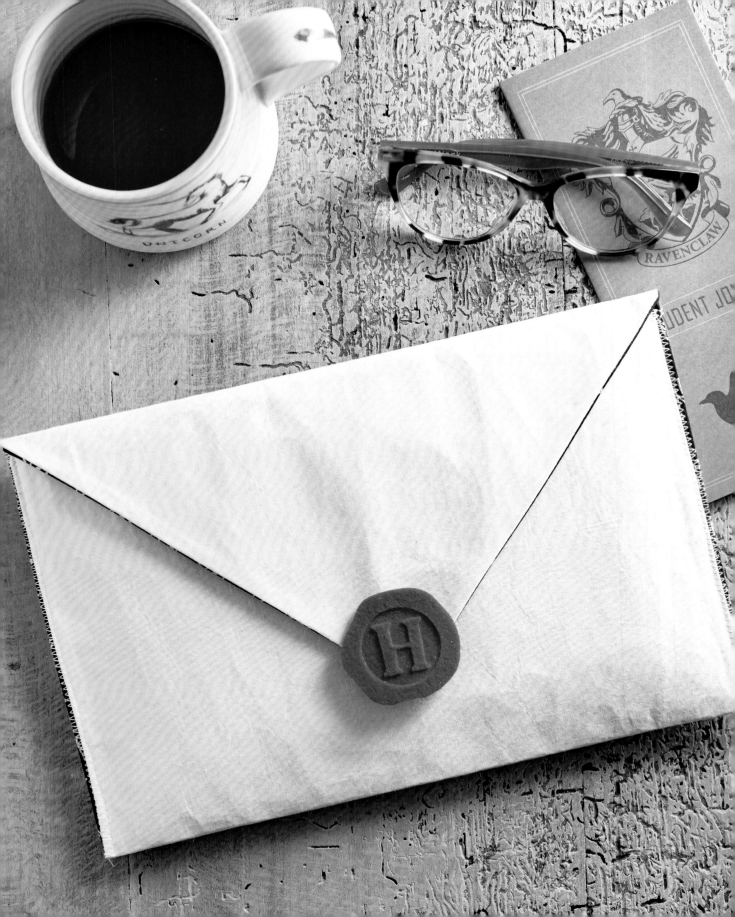

Chapter 2

Summer

"Promise you'll write this summer.
Both of you."

Hermione Granger, *Harry Potter and the Goblet of Fire*

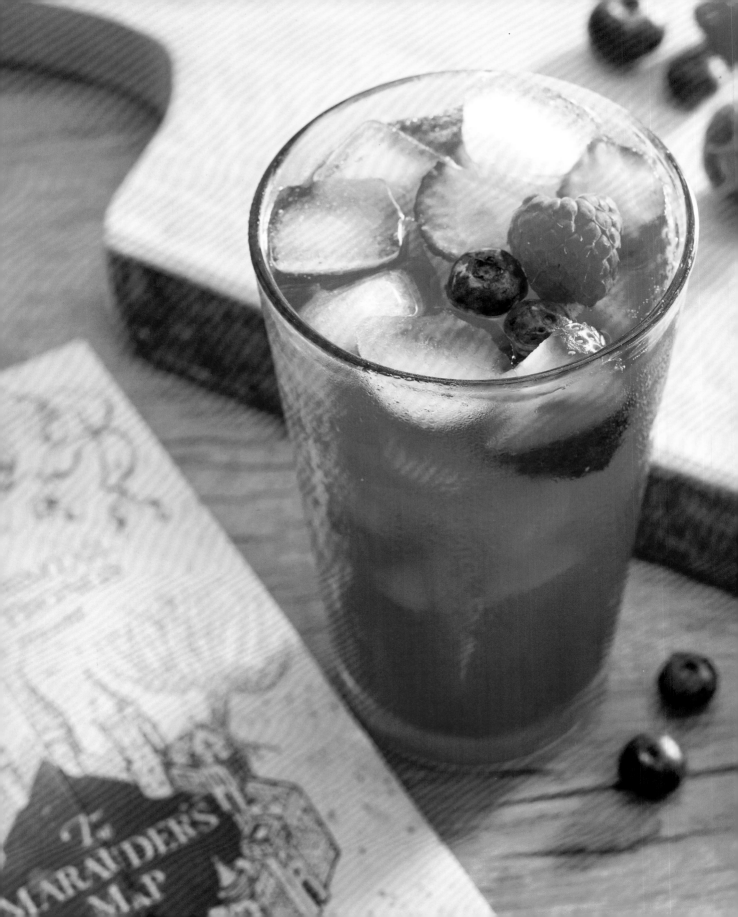

Marauders Mixed Berry Lemonade

The Marauder's Map in the Harry Potter films is a magical map created by Moony, Wormtail, Padfoot, and Prongs. The map is disguised as a regular piece of parchment until you tap it with your wand and say the phrase: "I solemnly swear that I am up to no good." Once spoken, the Marauder's Map reveals itself to be a detailed map of Hogwarts, showing the precise location of every inhabitant in the castle. In *Harry Potter and the Prisoner of Azkaban*, Harry is given the map, uses the map to follow secret passageways, and secretly visits Hogsmeade with Ron and Hermione.

The rowdy foursome, also known as the Marauders, caused all kinds of mischief during their time at Hogwarts and enjoyed spending time basking in the sun by the Black Lake. Like the four Marauders, this refreshing four-ingredient lemonade drink contains a mix of four different types of berries.

What you'll need

MAKES 4 DRINKS

- 3 cups (710 ml) water
- ¼ cup (59 ml) sugar
- ½ cup (118 ml) frozen mixed berries (blackberry, strawberry, raspberry, and blueberry)
- 2 tablespoons (30 ml) lemon juice

Instructions

1. In a medium pot, bring 1 cup of water and the sugar to a boil. Stir the mixture constantly until the sugar is dissolved.

2. Remove the mixture from the heat and set aside to cool.

3. In a blender, puree the berries until smooth. Use a strainer to remove the seeds.

4. In a pitcher, combine 2 cups of water, simple syrup (the sugar and water mixture), lemon juice, and pureed berries. Mix well using a large spoon or whisk.

5. Serve the lemonade with a generous amount of ice.

Behind the Magic

The mysterious Marauders from the map are actually code names for a group of four Gryffindors and classmates: Remus Lupin, Peter Pettigrew, Sirius Black, and James Potter. This group of young men weren't only clever wizards, but were Animagi, or wizards who can transform into an animal at will. Wormtail, otherwise known as Peter Pettigrew, could transform into a rat. Yes, the same rat we know as Scabbers, Ron's pet! Padfoot, a large black dog, is Sirius Black. James Potter, Harry's father, could transform into a stag, hence the nickname Prongs for his horns. The nickname Moony was for Remus Lupin, who was actually a werewolf. Unlike his Animagus friends, Remus Lupin could not transform at will, but only during a full moon. His three best friends learned to master being Animagi so that they could keep Remus under control during his transformation.

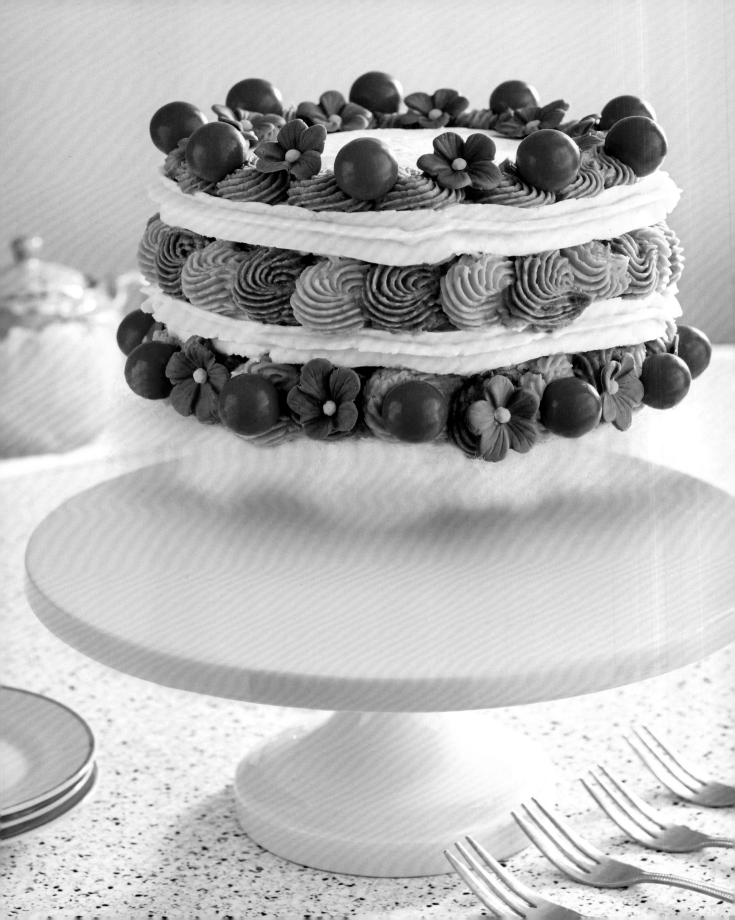

Petunia Dursley's Pudding Cake

During summer holiday at the Dursleys in *Harry Potter and the Chamber of Secrets*, Harry was preparing for his second year at Hogwarts when Dobby showed up to try and prevent him from going back to school. One evening, Petunia Dursley made a beautiful pudding for their dinner guests Mr. and Mrs. Mason. In an attempt to get Harry in trouble, Dobby uses a charm to move and drop the beautiful pudding on Mrs. Mason's head!

In Britain, the word "pudding" generally refers to the word "dessert," whereas in America, it refers to a specific milk-based custard-like dessert. It can also be a specific dish, like a custard, cake, or even a savory dish that has been boiled or steamed. In *Harry Potter and the Chamber of Secrets*, Petunia's Pudding has a custard texture rather than cake. Either way, who can say no to dessert?

Make your own miniature version of Petunia Dursley's Pudding Cake, covered with "a huge mound of whipped cream and sugared violets," to share with guests visiting this summer. Hopefully, this luscious dessert won't be ruined by a house-elf!

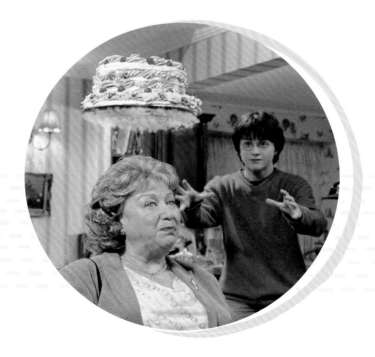

What you'll need

MAKES 2 MINI CAKES

Cake Ingredients:

- 15-to-18-ounce (425-to-510 g) white cake mix
- 3.4-ounce (96.4 g) package instant vanilla pudding mix
- 3 eggs
- ½ cup (118 ml) applesauce

Frosting & Decorating Ingredients:

- 1-pint (473 ml) heavy cream, chilled
- 1 cup (227 g) powdered sugar
- 1 teaspoon (5 ml) vanilla
- Food coloring in purple and green
- Red ball candies
- Purple candy flowers

Instructions

To make the cake:

1. In a mixing bowl, whisk the dry cake mix and dry pudding mix together.

2. Add in eggs and applesauce and mix well until combined.

3. Grease a 6-inch round cake pan and place a circle of parchment paper on the bottom to prevent the cake from sticking.

4. Pour half of the cake batter into the pan. Do not fill the pan more than ¾ full.

5. Bake the cake at 350° F for 30 to 40 minutes. When a toothpick poked in the center comes out clean, the cake is done.

6. Let it cool for 10 minutes and then flip the cake out of the pan and onto a cooling rack to finish cooling.

7. Cut the cake in half, horizontally, and place the bottom section onto a cake plate.

To make the frosting:

8. Using a stand or hand mixer, whip the heavy cream until frothy.

9. Slowly add in powdered sugar and vanilla while still mixing the heavy cream.

10. When the mixture reaches a thicker, frosting consistency, it is ready to use.

11. Separate the frosting into three bowls. Add purple food coloring to one bowl of frosting and green food coloring to another bowl. Leave the last bowl of frosting white. Mix each one well until the color is evenly distributed.

12. Spoon the three frostings into piping bags. For a decorative look to the cake, use a star piping tip.

To decorate:

13. Add a layer of white frosting to the top of the bottom half of the cake.

14. Place the other half of the cake on top.

15. Frost the entire cake with white frosting.

16. Pipe a line of white frosting along the top edge of both cakes.

17. At the bottom of the cake, alternate swirls of purple and green frosting.

18. Add more alternating swirls around the center of the cake, between the lines of white frosting.

19. Pipe purple swirls around the entire top edge of the cake.

20. Add red ball candies on top of the green swirls along the bottom of the cake, and in between the purple swirls on top.

21. Place purple candy flowers onto the purple swirls on the bottom of the cake and then put some randomly on the top of the cake.

TIP:

Whipping the heavy cream goes a lot faster if both the bowl and beaters are also chilled.

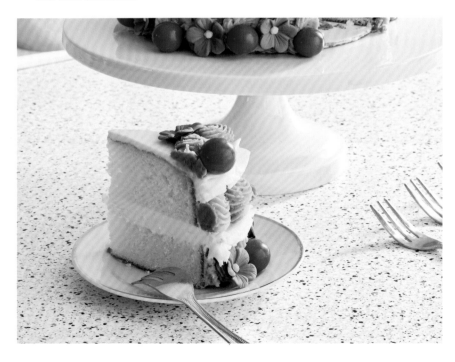

Behind the Magic

All of the Dursley scenes were filmed completely separate from the Hogwarts scenes. Because of this, the Dursley family actors never really witnessed anything filmed in the magical world. The family and Harry created quite the bond while filming, and they actually all enjoyed each other's company. Richard Griffiths, the actor portraying Uncle Vernon, often asked to go onto the Hogwarts set to watch the filming. He was denied multiple times, and once asked J.K. Rowling if it would be possible to write in a "parents weekend at Hogwarts" so that the Dursleys could come be part of the magic. She immediately said no.

"Well, we have ice cream . . ."

—Petunia Dursley, *Harry Potter and the Chamber of Secrets*

Patronus Night Lights

Expecto Patronum! The Patronus Charm is one of the most famous and advanced defense charms Hogwarts students learn. When cast, the Patronus takes on the form of a unique creature powered by positive forces to protect the wizard from Dementors. Harry is one of the youngest wizards to conjure a Patronus, which takes the form of a stag (just like his father). In his fifth year, Harry conjured the Patronus that saved Dudley from a rogue Dementor attack during his summer holidays.

Casting a Patronus is no easy task, especially for filmmakers! To help create a Patronus glow, a real dog was dressed in an LED vest as a stand-in for the stag. Did you know that according to the wizarding world, a cat and a dolphin are the top two most popular Patronus forms? Alternatively, one of the rarest forms is a stag! No matter your wizarding skill level, you can conjure your own Patronus as a night light on warm summer nights to protect you from the dark. Feel free to use one of the provided templates in the book, or download alternatives at www.insighteditions.com/harrypotterhomemade depending on what your preferred patronus is.

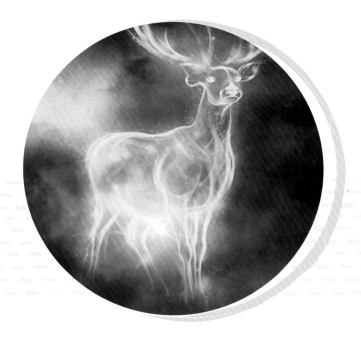

What you'll need

- Patronus template, pages 58–59
- Pencil
- 9.8-by-6.5-inch (24.892-by-16.51 cm) wood canvas
- Craft knife
- Sandpaper
- Black acrylic paint
- Blue vellum paper
- Tape or glue
- LED fairy lights (with battery pack)

Instructions

1. Download or trace the Patronus template (pages 58–59) onto a piece of copy paper. Turn the paper over and scribble with a pencil at an angle to rub a layer of pencil lead all over the back.

2. Center the template on the underside of the wood canvas and tape it down to hold it in place.

3. Trace over the entire Patronus design with a pencil using a good amount of pressure.

4. When you peel the design away, the image will have been transferred to the wood like magic!

5. Place the canvas onto a cutting mat or a scrap piece of wood. Use a sharp craft knife to cut the design out of the wood. For best results, go over the design multiple times with minimal pressure.

6. After you cut the design out of the canvas, use some sandpaper to gently smooth out any rough areas.

7. Turn the canvas over and paint the entire front and sides with black acrylic paint. You may need more than one coat for full coverage. Be sure to let each coat of paint dry completely before adding another. Let the paint dry completely before

moving on to the next step.

8. Cut a piece of blue vellum slightly larger than the design. Turn the canvas over and place the vellum on the underside of the canvas and use tape or glue to hold it in place.

9. Last, attach a string of fairy lights to go all the way around the design, centered between the edge of the frame and the opening. Hold the light string in place with tape or glue.

10. Turn the light on and then hang the canvas on the wall to put your glowing Patronus on display.

TIPS:

- When cutting the template, start with cuts that are perpendicular to the wood grain and don't use too much pressure to help prevent the wood from breaking or chipping off.

- Check out the other patronus templates online at www.insighteditions.com/ harrypotterhomemade

Behind the Magic

There was a lot of testing for the films to get the Dementors just right. They started with shooting puppets of Dementors underwater. The way they moved in the water gave them an eerie effect, and even more so when played backwards. Unfortunately, they couldn't film all the scenes underwater, so they used references from the puppeteer footage to create the kinds of movements and textures to achieve the visual effects.

" A Patronus is a kind of positive force, and for the wizard who can conjure one, it works kind of like a shield with a Dementor feeding on it, rather than him. But in order for it to work, you need to think of a memory. Not just any memory, but a very happy memory, a powerful memory."

—Professor Lupin, *Harry Potter and the Prisoner of Azkaban*

Patronus Templates

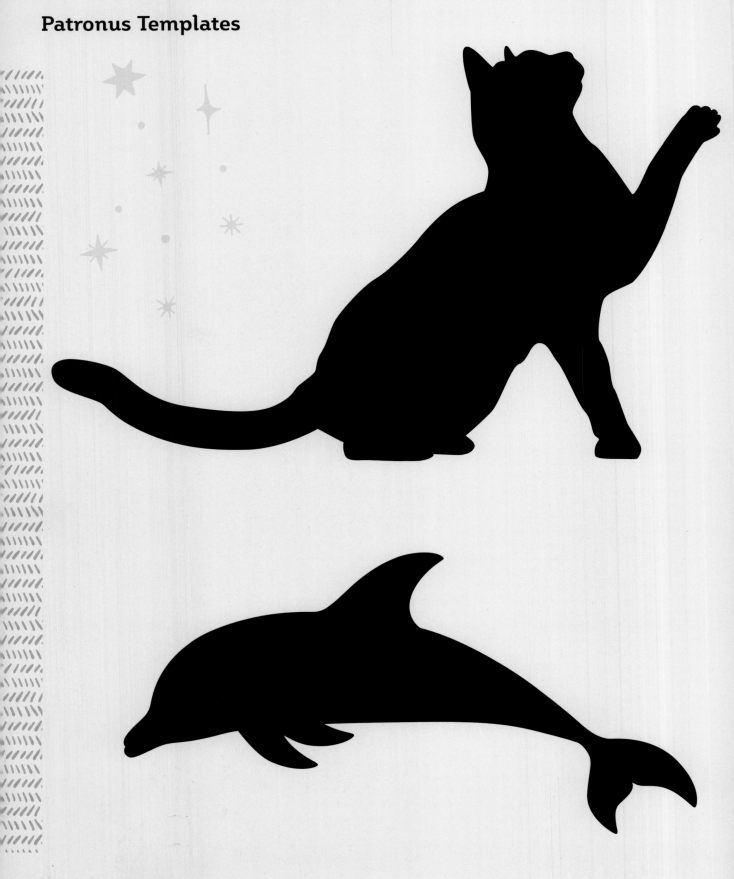

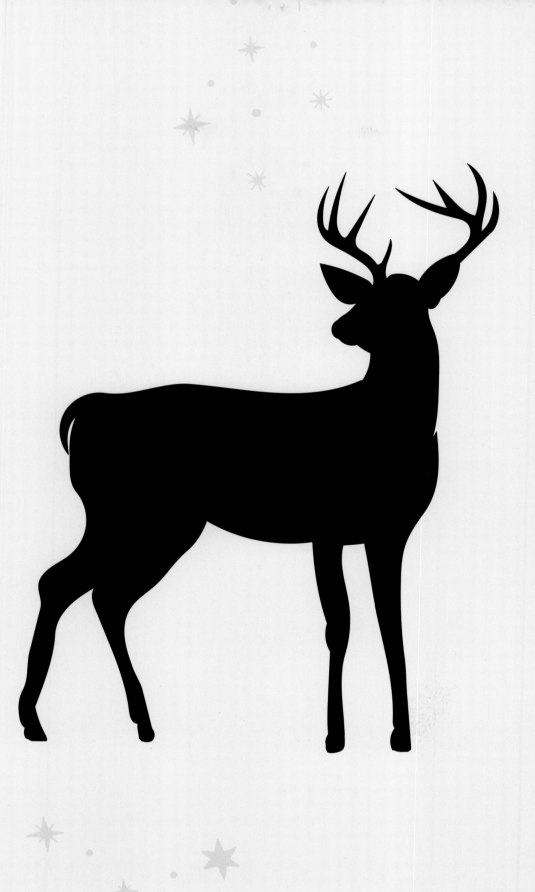

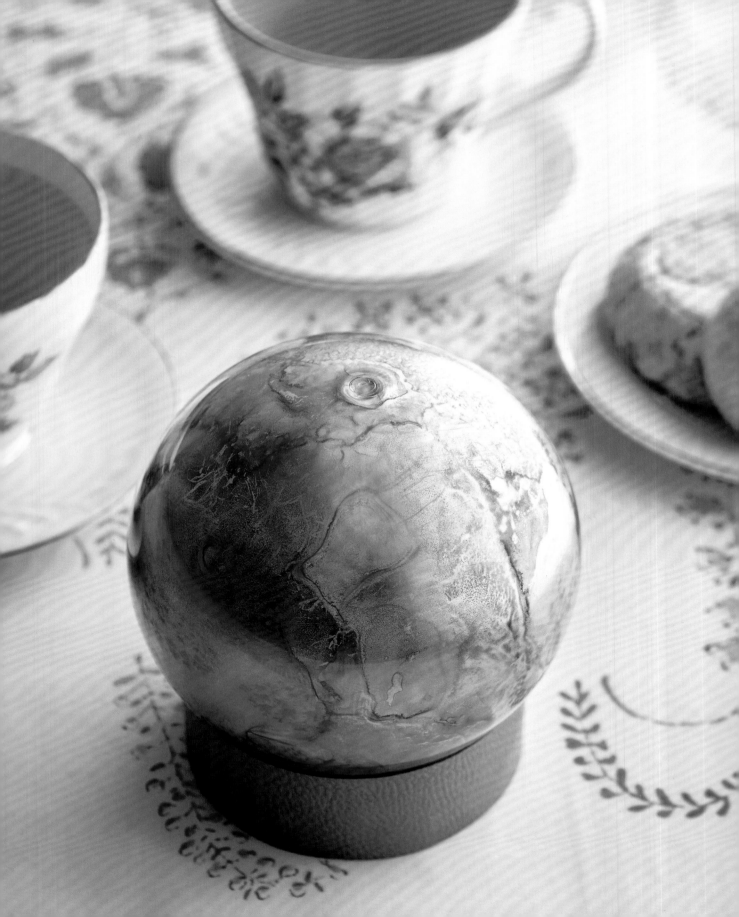

Professor Trelawney's Divination Orb

Sybill Trelawney is a seer and professor of Divination at Hogwarts and was the one who made the famous prophecy about "The one with the power to vanquish the Dark Lord." When Harry was in her class, Trelawney often made many vague predictions about students using her orb and gift of sight. During a class on reading tea leaves, Trelawney looked into Harry's teacup and saw the "Grim," which takes the form of a black dog and is one of the worst omens of death.

Seers, like Professor Trelawney, use magical crystal spheres to gaze into when divining the future. Create your own Divination orb as a summer project to practice your own orb-reading skills. What fun activities will you be looking forward to this summer? Take a look and see what the orb says!

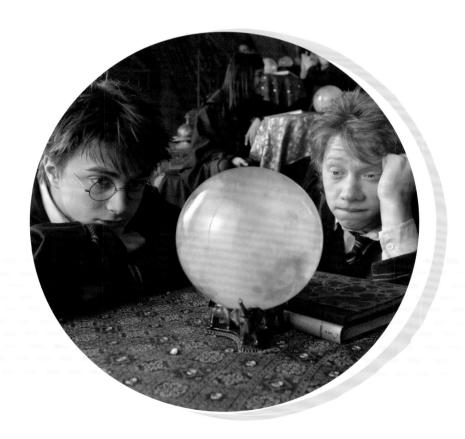

What you'll need

- 4-inch (10.16 cm) plastic snow globe
- Isopropyl (rubbing) alcohol
- Alcohol inks: blue, silver
- Straw or compressed air can
- Transparency film
- Permanent marker, black
- 10 to 15 cotton balls
- Metallic faux leather
- Hot glue and glue sticks

Instructions

1. Open a snow globe and add in a few drops of alcohol. Swirl it around the globe.

2. While the alcohol is still wet, add in a drop of blue alcohol ink. Use a straw or compressed air to blow the ink around until it dries. Keep adding ink and blowing it around until you like how it looks.

3. For added shimmer, add a few drops of metallic silver alcohol ink inside the globe and blow it around.

4. Cut out a 3.75-inch (9.525 cm) circle of transparency film. With a black permanent marker, fill the circle with your own dotted "Grim" image. Let the marker ink dry completely before touching it!

5. Grab 10 to 15 cotton balls and tear them into small pieces. Place the cotton ball pieces into the globe.

6. Carefully place the transparency "Grim" into the globe and do your best to make it stand up with the cotton behind it.

7. Place the globe cap back on and twist the outer base on.

8. Cut a piece of metallic faux leather so that it's the same height of the base and fits all the way around. Use hot glue to hold the leather in place.

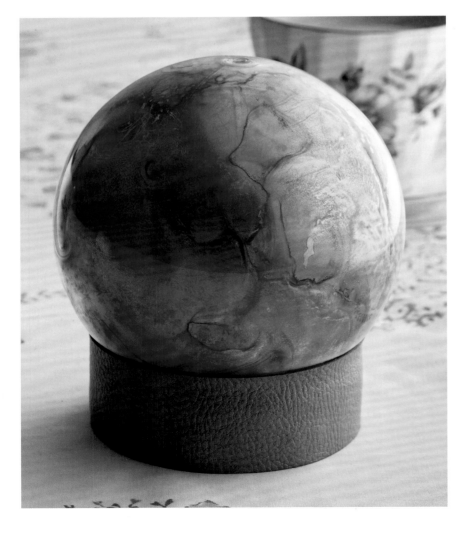

Behind the Magic

Trelawney is one unique character. Her glasses in the film actually are magnifying glasses to make her eyes appear enormous. Seers like Professor Trelawney see into the future all the time, but the glasses actually made it so that actress, Emma Thompson, literally couldn't see anything at all in the present when she was wearing them!

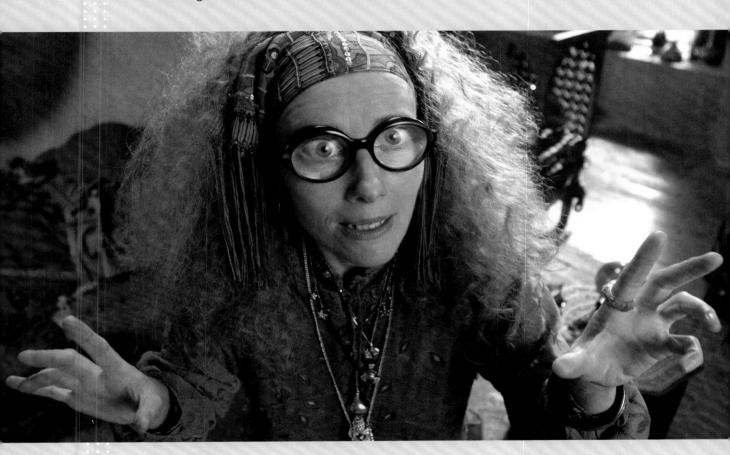

"The one with the power to vanquish the Dark Lord approaches, and the Dark Lord shall mark him as his equal, but he shall have power the Dark Lord knows not. For neither can live while the other survives."

—The Prophecy (Professor Trelawny's voice), *Harry Potter and the Order of the Phoenix*

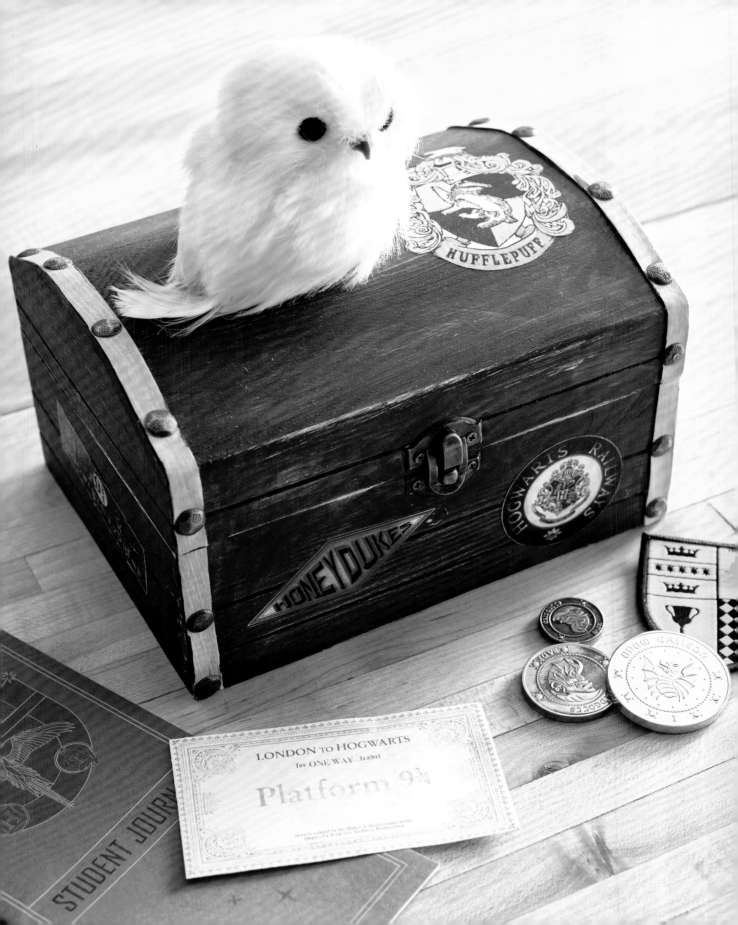

Hogwarts Trunk Trinket Box

Growing up, back-to-school shopping . . . it can all feel like the grand finale to summer. As exciting as school shopping is, we can only imagine how it would feel as a Hogwarts student to hit the shops in Diagon Alley!

The Hogwarts Express, the train Harry and his classmates take to Hogwarts every year, is reached by going to Platform 9¾ at King's Cross station. The scenes filmed at the platform location required multiple pieces of luggage for the students boarding the train—most importantly, the customized trunks for the main characters with their initials on the side and the school crest stamp on the top. The luggage props weren't just for the students. Stephenie McMillan, a set decorator for the films, recalled often visiting various pet shops to try to find as many unique cages as possible for students to keep their owls, rats, cats, and other animals.

Like Hogwarts students traveling on the Hogwarts Express at the end of summer, this tutorial will help you to create your own custom Hogwarts Trunk Trinket Box. Not only does it look like a student trunk, it's also a functional piece for organizing your jewelry, trinkets, school supplies, and more!

What you'll need

- 5-by-7-inch (12.7-by-17.78 cm) latched wood chest
- Sandpaper
- Acrylic, paint, brown
- 1-inch (2.54 cm) paint brush
- 2 sheets heavy cardstock or chipboard
- 12-by-24-inch (30.48-by-60.96 cm) fleece or plush fabric
- Hot glue and glue sticks
- 3-inch (7.62 cm) "companion animal" figure (owl, cat, toad, etc.)
- Hogwars Trunk Trinket Box Decals, page 157 ⬇

Instructions

1. Sand the wood chest to remove any rough edges, if necessary.

2. Paint the outside of the chest with brown acrylic paint. You may need more than one coat for full coverage.

3. Let the paint dry completely and then use the sandpaper to "roughen" up the paint. The key is to make the trunk look like it's made the trip to Hogwarts a few times.

4. Measure each section of the inside of the box and write the measurements down. This will make it easier to line the box with fabric.

5. Cut pieces of heavy cardstock or chipboard to fit each section of the inside of the box.

6. "Dry" fit the pieces to the inside of the box (meaning to put the pieces in the box without adhesive first to make sure that they fit). This way you can easily remove them to make any adjustments, if necessary.

7. Cut a piece of fabric about ½ inch larger than each paper template. Lay the fabric face-down and place the paper in the center. Cut each corner of fabric at an angle and then fold each side up and over the paper. Use adhesive to hold the edges in place.

8. Place hot glue on the inside of the box, one side at a time. Line the fabric/paper rectangle into place and hold it until the adhesive is set. Repeat for each section of the box until the entire inside is lined.

9. Close the trunk, place your companion animal figure on top, and use adhesive to keep it in place.

10. Remove or download the desired decals from page 157, and use adhesive to decorate the outside of the trunk to fit your wizarding personality.

11. Fill your school trunk with anything that you want! It's a great size for jewelry, trinkets, wand pens, and more!

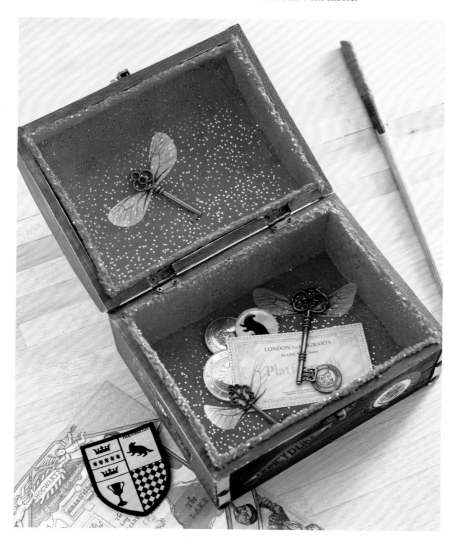

Behind the Magic

In *Harry Potter and the Sorcerer's Stone*, director Chris Columbus wanted the inside of the Hogwarts Express to have the look and feel of the train that John, Paul, George, and Ringo rode in during *A Hard Day's Night*, a Beatles film from 1964, which was also Chris's favorite film of all time.

"All you have to do is walk straight at the barrier between platforms nine and ten. Focus . . . but don't stop and don't be scared you'll crash into it either. Best do it at a bit of a run if you're nervous."

—Molly Weasley, *Harry Potter and the Sorcerer's Stone*

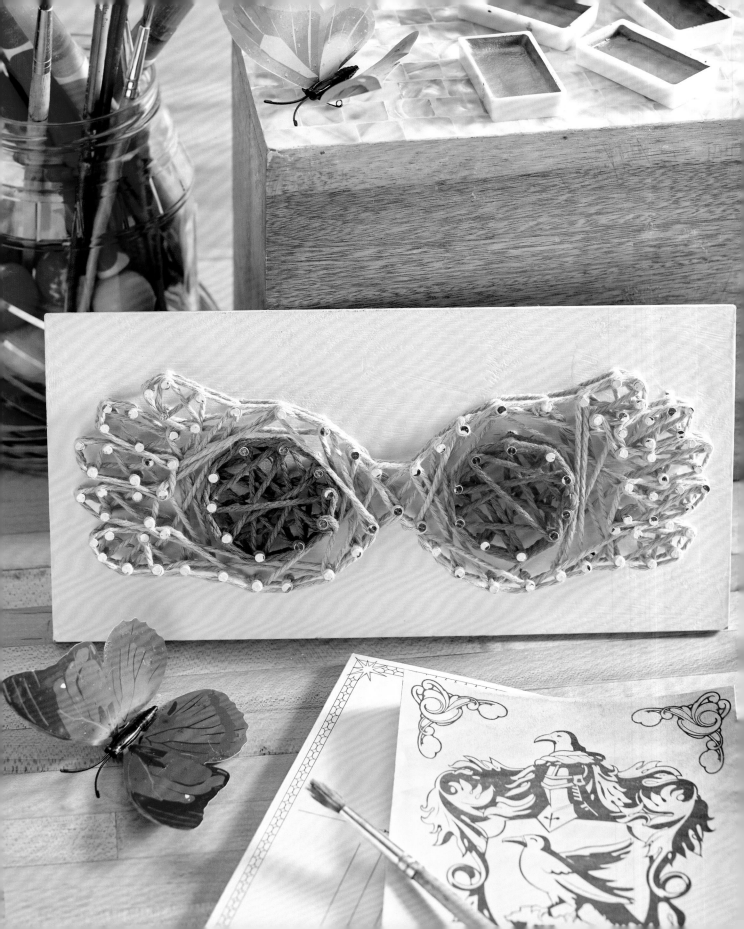

Luna Lovegood's Spectrespecs String Art

Everyone loves a good pair of sunglasses in the summer, and no one can rock a pair of Spectrespecs like Luna Lovegood! In the films, Spectrespecs are large, colorful glasses that were given away for free in an issue of *The Quibbler* magazine. When Harry was riding on the train with Luna and Neville in *Harry Potter and the Half-Blood Prince*, Luna was wearing this interesting pair of Spectrespecs. She claimed that the glasses allowed the wearer to see Wrackspurts, invisible creatures that "float in through your ears and make your brain go fuzzy."

Luna is never afraid to be herself and says exactly what's on her mind. A true Ravenclaw, Luna is clever, witty, quirky, a loyal friend, and has a knack for finding creative solutions to any problem. In the films, Luna's mismatched costumes were mostly purple and blue hues, with fabrics often featuring animals or natural elements for a folk art feel. Jany Temime, a costume designer for the films, always felt that Luna lived in "her own homemade world. You felt she was a kid who collected insects or animals. She has an approach to the world that nobody else has. And I always wanted to reflect that in her clothing. I think it mattered."

Luna's Spectrespecs are iconic to her character. They are a little bit strange and very different from other glasses, but it's their uniqueness that makes them special. This Spectrespecs String Art project reminds us to be more like Luna Lovegood and spend more time walking barefoot in the summer grass!

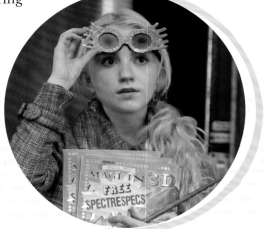

What you'll need

- 5-by-10-inch (12.7-by-25.4 cm) wood rectangle
- White acrylic paint
- Paint brush
- Spectrespecs template, page 71 ⬇
- Tape
- 120 one-inch (2.54 cm) white nails
- Hammer
- 1 yard (91.44 cm) light pink string
- ½ yard (45.72 cm) dark pink string
- ½ yard (45.72 cm) blue string
- Hanger, optional

Instructions

1. Paint the wood board with acrylic paint. You may need more than one coat. Remember to let the paint dry completely before adding another coat.

2. Download or trace the Spectrespecs template on page 71 to a separate piece of paper. Center the Spectrespecs template on the board and use tape to keep it in place.

3. Use a hammer to add nails, each about ½-inch apart around the entire border of the design. (Make sure to put a scrap board or something down under your project to protect your workspace in case the nails poke through the back!)

4. Remove the template from the board, tearing it away from the nails.

5. Tie the blue string to one of the nails outlining the left lens and trim the end short.

6. Wrap the string randomly around each of the nails to fill in the lens area. Then, wrap the string around the edges to create a border around the lens shape. Tie the string off and trim.

7. Repeat steps 5 and 6 using the dark pink string on the right lens.

8. Lastly, use the light pink string to outline and fill in the rest of the Spectrespecs. When you are done, tie off the string and trim the end. Be sure to tuck all the trimmed ends into the string so that they aren't showing.

9. Attach a hanger to the back of the board so that you can display your magical string.

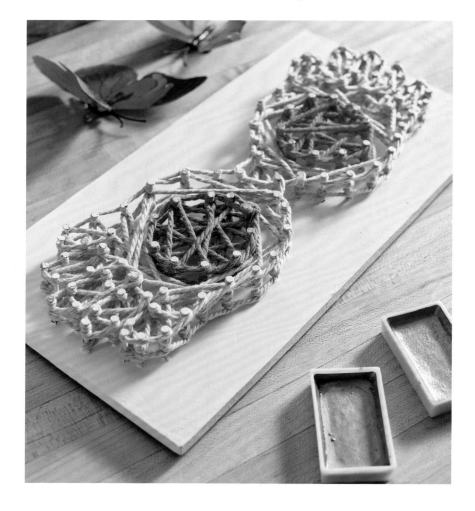

Spectrespecs Template

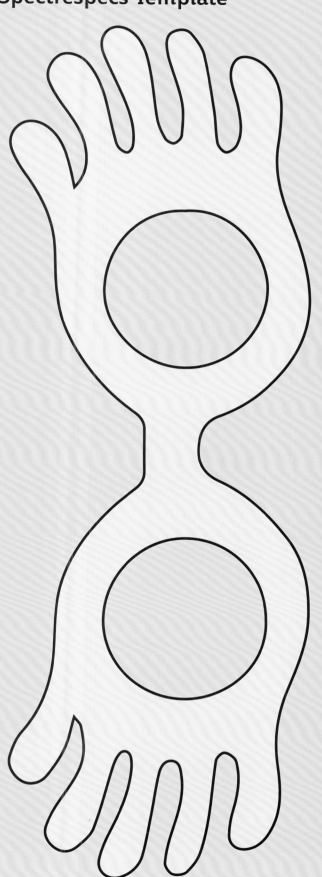

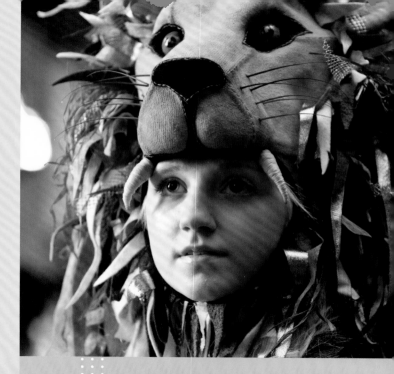

Behind the Magic

Evanna Lynch, the actress who played Luna, is just as unique as the character she plays. She actually made her own beaded dirigible plum earrings and the lion headdress for the films! Costume and set designers were inspired by her creativity and implemented her ideas into Luna's costumes and decor of the Lovegood house.

"You're not going mad. I see them, too. You're just as sane as I am."

—Luna Lovegood, *Harry Potter and the Order of the Phoenix*

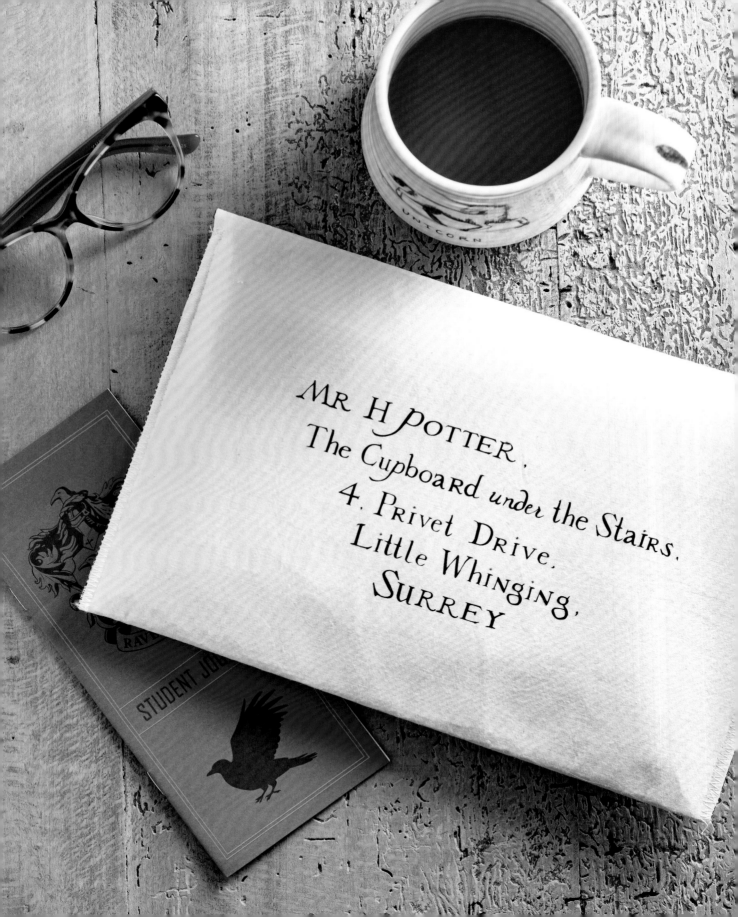

Hogwarts Letter Clutch

Official Hogwarts acceptance letters arrive the summer of the year that a wizard turns eleven, which is a pretty exciting moment for a young wizard! This letter, written on parchment, contains a note of acceptance from the Headmaster or Headmistress of Hogwarts, along with a list of required supplies for the upcoming school year. Letters are delivered to wizards by owl and to Muggles by regular post.

Those of us who are yearning to attend Hogwarts are still waiting on our letters to arrive. While we eagerly await an owl to peck at our doors this summer, you can make your own Hogwarts Letter Clutch, complete with wax seal, to hold all your personal items.

What you'll need

- 1 fat quarter (50-by-55 cm) white cotton fabric
- 1 fat quarter (50-by-55 cm) cotton fabric (in any pattern)
- Fusible interfacing (made for crafts)
- Cutting mat and rotary cutter
- Iron
- Sewing machine, optional
- Sewing pins or clips
- Chopstick or fabric turning tool
- Hook and loop fastener
- Fabric adhesive
- Hogwarts Seal template ⬇
- Red felt
- Scissors
- Harry Potter Address template ⬇
- Black fabric marker or heat transfer vinyl

Instructions

1. Cut both fabrics and interfacing to measure 12-by-21.5 inches (30.48-by-54.61 cm), using a cutting mat and rotary cutter.

2. Make a mark at the center on one of the short sides of the fabric. Fold the corners in (like making a paper airplane) so that the top is now at a point. Iron over the folded edges and then cut along the creases to remove the top two corners. Repeat this step for both fabrics and the interfacing.

3. Turn the white fabric right-side down, and place the fusible interfacing with the glue-side down on the fabric. Use your iron (and follow packaging instructions) to attach the interfacing to the fabric.

4. Lay the fabrics together, with the right sides together. Sew all the way around with a ¼-inch seam allowance, leaving a 4-inch (10.16 cm) opening at the bottom.

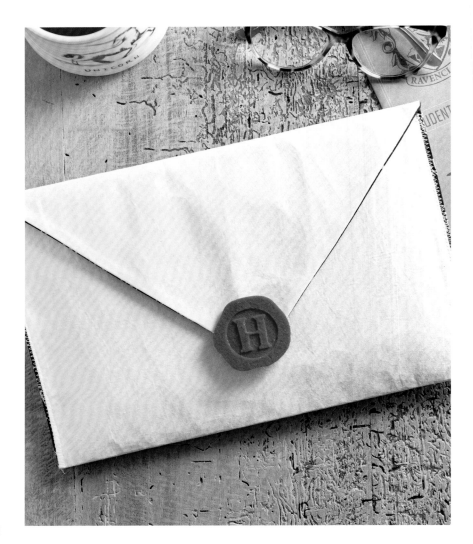

5. Cut all the corners at an angle, being careful to not cut through the seams. This will help your corners to have a sharper point.

6. Turn the clutch right-side out through the opening. Use a chopstick or a turning tool to poke the corners out.

7. Press the seams down with an iron and fold the opening fabric in ¼ inch (0.635 cm) for the seam allowance. Pin or clip the opening closed.

8. Sew across the length of the bottom of the clutch with a wide zig-zag stitch, letting the needle go just off the edge of the fabric.

9. With the point of the fabric at the top and the lining fabric facing up, fold the bottom edge up 7 inches (17.78 cm). Pin or clip both side edges together.

Continued on page 76

10. Sew both sides with a wide zig-zag stitch, letting the needle go just off the edge of the fabric. Be sure to backstitch at both the top and bottom of each side.

11. Fold the pointed edge down and iron it to create a crease.

12. Cut a small piece of hook and loop fastener and stick them together. Apply a small amount of fabric adhesive to the back of each piece and then put it on the underside of the pointed envelope edge. Fold it down, like closing an envelope, and hold it in place until the adhesive has set. When it's dry, you should be able to open the envelope and have the hook and loop fastener pieces attached to both the flap and the main clutch.

13. To give the letter clutch a more "official" look, download, print, and trace the Hogwarts Seal template from www.insighteditions.com/ harrypotterhomemade. Cut the pattern out of red felt. Attach the pieces together with fabric adhesive. When it's dry, attach the seal to the pointed part of the flap with more fabric adhesive.

TIP:

Download the Harry Potter Address template from www.insighteditions.com/ harrypotterhomemade and then apply it to the front of the clutch by hand with a fabric marker, or cut it out of heat transfer vinyl and apply it to the front using an iron.

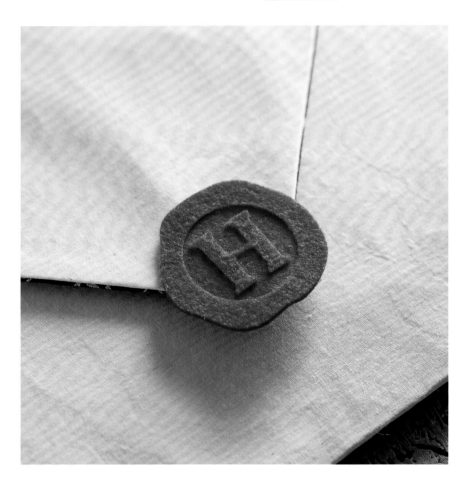

Behind the Magic

In *Harry Potter and the Sorcerer's Stone*, filming the scene with a barrage of Hogwarts letters flying into the Dursley home was actually a lot of fun! Rigs with an air device were built to throw the envelopes out of the chimney at a very rapid, but controlled, speed into the Dursleys' faces. Rigged envelopes were also placed all the way around the set so that it would appear that the letters were coming into the Dursley home from every angle.

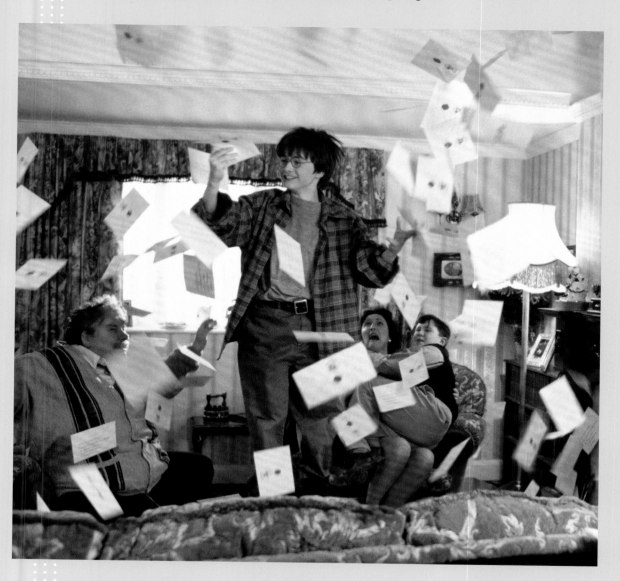

Chapter 3

· · · · · · · · · · · · · · · · · · · ·

Autumn

"Welcome, welcome to another
year at Hogwarts."

Albus Dumbledore, *Harry Potter and the Prisoner of Azkaban*

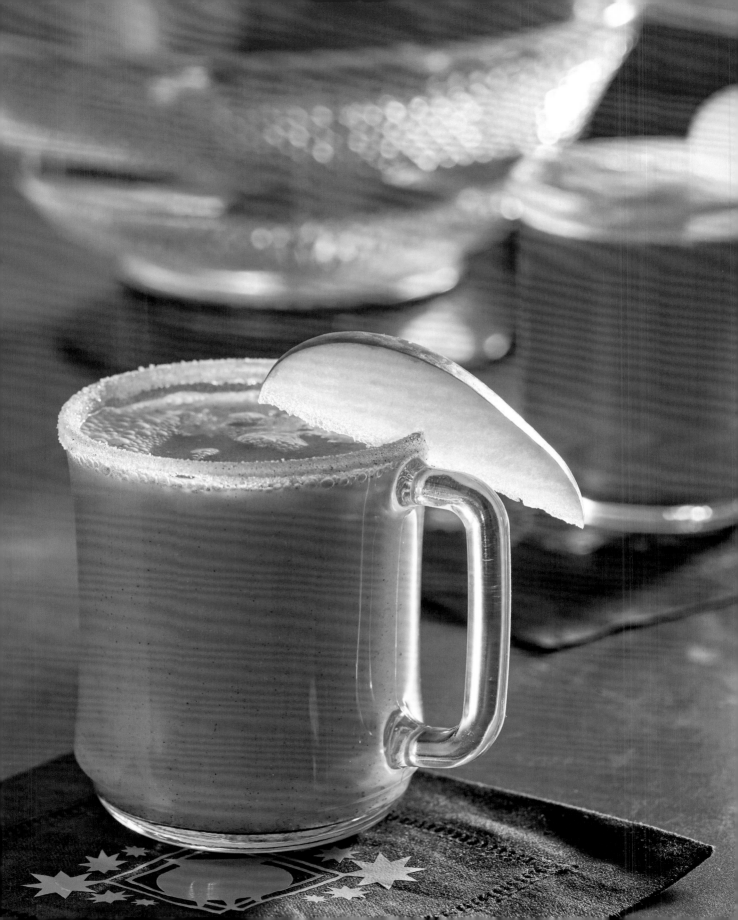

Slughorn's Caramel Apple Warmer

Horace Slughorn, a retired Hogwarts Potions Master, enjoyed throwing invite-only parties for "the Slug Club." The members of this exclusive club were hand-picked by Slughorn himself; they were Hogwarts students with exceptional talents or had some kind of famous or influential connection. Slug Club parties were lavish, with only the best food, decor, and entertainment. In fact, I'm sure that this decadent Caramel Apple Warmer is one that Slughorn would be proud to serve at one of his parties!

Jim Broadbent, the actor behind the infamous Potions Professor Horace Slughorn, has played a variety of characters in more than one hundred films! *Harry Potter and the Half-Blood Prince* offered him a new acting challenge: "When we first meet my character," he explains, "I am disguised as an armchair." When asked if he had any experience in his long career he could draw upon, he answered, "I did a voice-over of a lavatory seat once. But this is my first real chair."

What you'll need

- 1½ cups (355 ml) apple cider
- 1½ tablespoons (22 ml) caramel sauce
- ½ teaspoon (2.5 ml) vanilla
- ½ teaspoon (2.5 ml) pumpkin pie spice
- ½ teaspoon (2.5 ml) granulated sugar
- ½ teaspoon (2.5 ml) cinnamon

Instructions

1. In a saucepan on low heat, add in the apple cider, caramel sauce, vanilla, and pumpkin pie spice.

2. Turn the heat up to medium and stir constantly until the caramel has dissolved.

3. Add a line of caramel around the rim of the glass and dip it in a sugar and cinnamon mixture.

4. Carefully pour the drink into the glass. It will be hot, so use caution when handling the glass.

5. Garnish the glass with an apple slice and enjoy!

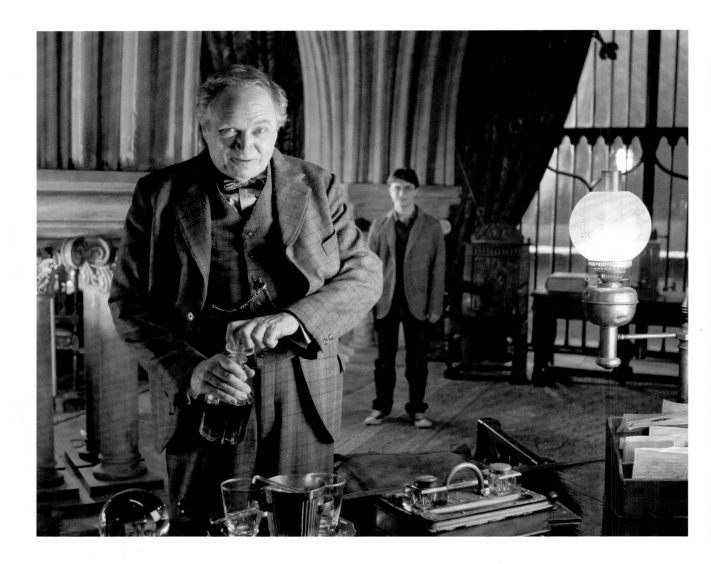

Behind the Magic

Jany Temime, costume designer for the films, sourced the lilac-colored material that transformed Slughorn's chair upholstery into his pajamas, but this was just the first piece of Slughorn's extensive wardrobe. During filming, both the costume and set designers worked together to match Professor Slughorn's surroundings with his fashion style. The Slug Club dinner parties were always held in his office, so a large, round table to seat thirteen people was added, along with carved chairs and brown leather furniture around the room. Brown silks were hung on the walls with luxurious brown curtains to match.

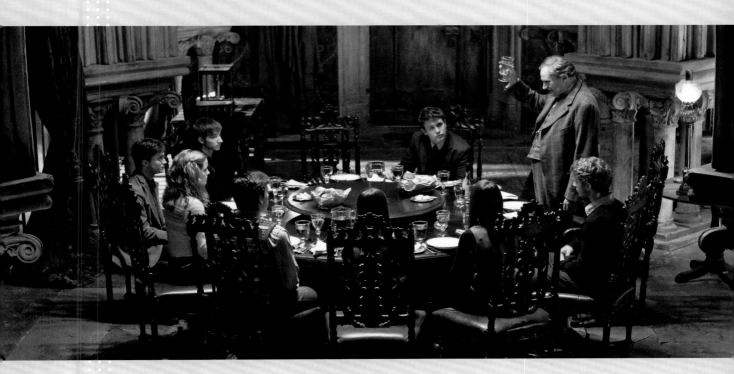

"Some of your classmates . . . Well, let's just say they're unlikely to make the shelf."

[Slughorn points to a wall of portraits of past "Slug Club" members]

"Anyone who aspires to be anyone ends up here. But then again, you already are someone, aren't you, Harry?"

—Horace Slughorn, *Harry Potter and the Half-Blood Prince*

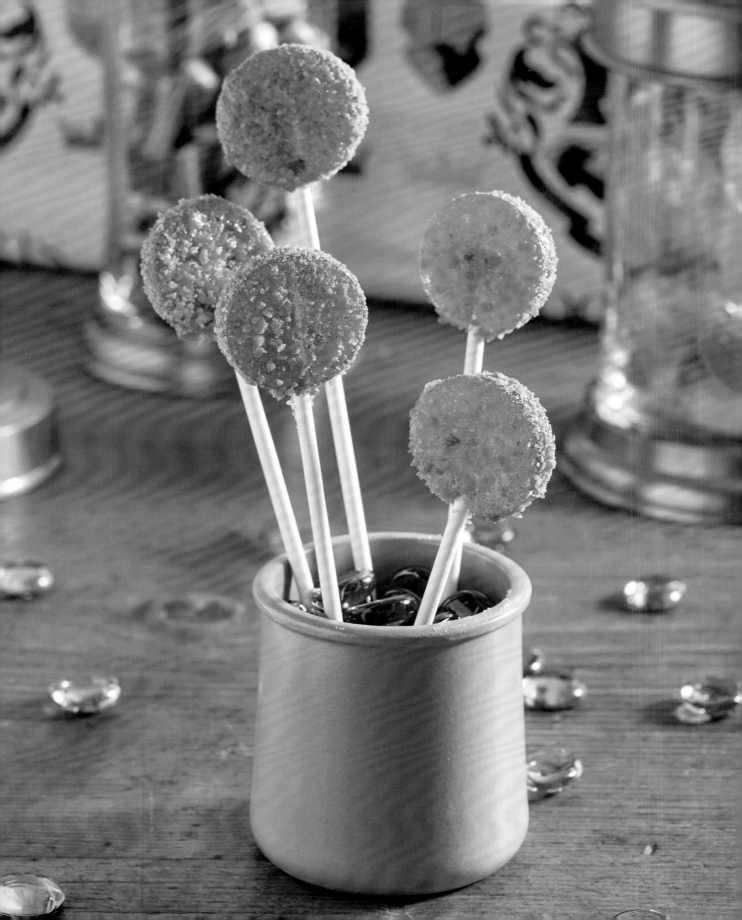

Pixie Pop Lollipops

Cornish pixies are small, electric-blue mischief-makers that love playing tricks and practical jokes on anyone they can. At the beginning of term in *Harry Potter and the Chamber of Secrets*, Professor Lockhart released pixies in the classroom for a Defense Against the Dark Arts lesson and quickly lost control of them. The pixies wreaked havoc on the students, and it was Hermione who used her smarts to stop them with a freezing charm.

These Pixie Pop Lollipops are inspired by the mischievous Cornish pixies. They look pretty, but these lollipops are an electric-blue, tricky treat that would be a lot of fun to "set loose" on unsuspecting friends during Halloween festivities.

What you'll need

MAKES TWENTY-FOUR 1½-INCH LOLLIPOPS

- Silicone 1½-inch (3.81 cm) lollipop mold
- 24 lollipop sticks
- 1 cup (236.5 ml) sugar
- ½ cup (118.3 ml) light corn syrup
- ¼ cup (59 ml) water
- Candy thermometer
- 1½ teaspoons (7.4 ml) candy flavoring
- Blue food coloring
- 4 to 5 packages blue popping candy

Instructions

1. Lightly grease the lollipop mold with a paper towel dipped in non-stick cooking spray to prevent the candy from sticking.

2. Place the lollipop sticks into the mold cavities.

3. In a saucepan, heat up the sugar, corn syrup, and water over medium-high heat.

4. Stir the mixture constantly until the sugar has dissolved.

5. When the mixture starts boiling, insert a candy thermometer. Let it boil until the temperature reaches 290° to 300° F (143° to 149° C).

6. Remove the saucepan from the heat and stir in the flavoring and blue food coloring.

7. Immediately spoon the candy mixture into the mold cavities, making sure to fill them enough to cover the sticks.

8. Let the lollipop cool completely and then remove them from the mold.

9. Pour the popping candy into a small bowl or cup.

10. Wet a paper towel and then wring it out so that it's damp. Rub both sides and the edges of each lollipop with the paper towel to get it damp (not wet). Dip the lollipop into the bowl or cup to coat it in the popping candy.

11. Place the covered lollipops onto a plate or stand them on some Styrofoam to dry.

TIPS:

- If the sugar mixture starts getting cool/too thick to pour, put it back on the heat to warm it back up.

- Some of the popping candy will activate when first added to the lollies, so be prepared for a little reaction!

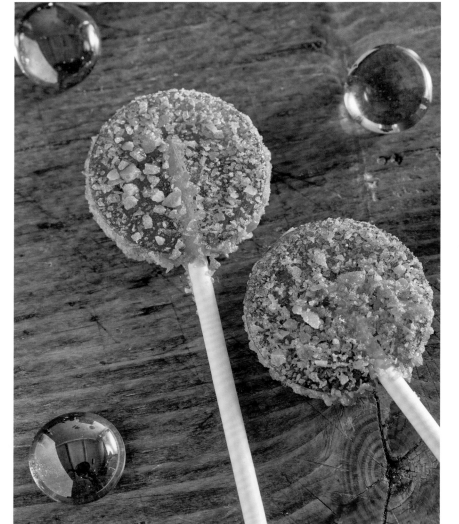

Behind the Magic

When Professor Lockhart releases the Cornish pixies during his first lesson, the pixies knock books off the shelves and pull the students' hair. These tricks were done with practical effects, performed by using thin wires. For the films, a model of a Cornish pixie was made and then scanned in to create a digital animation. To give the pixies something to hold on to in *Harry Potter and the Chamber of Secrets*, Neville had to wear fake ear tips attached to wire to be lifted by the pixies! If you look closely in *Harry Potter and the Deathly Hallows: Part 2*, there is a nest of Pixies hidden in the room of requirement.

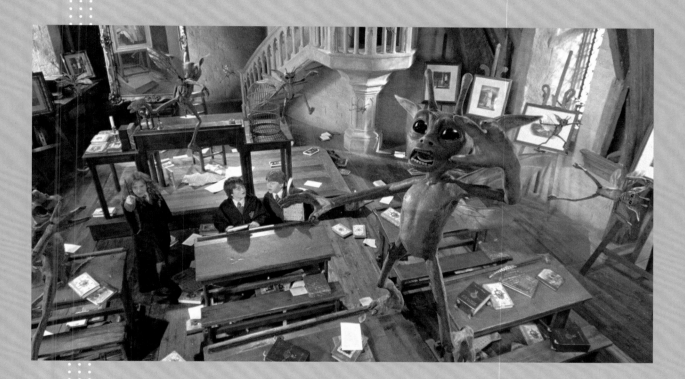

"Laugh if you will, but pixies can be devilishly tricky little blighters! Let's see what you make of them."

—Gilderoy Lockhart, *Harry Potter and the Chamber of Secrets*

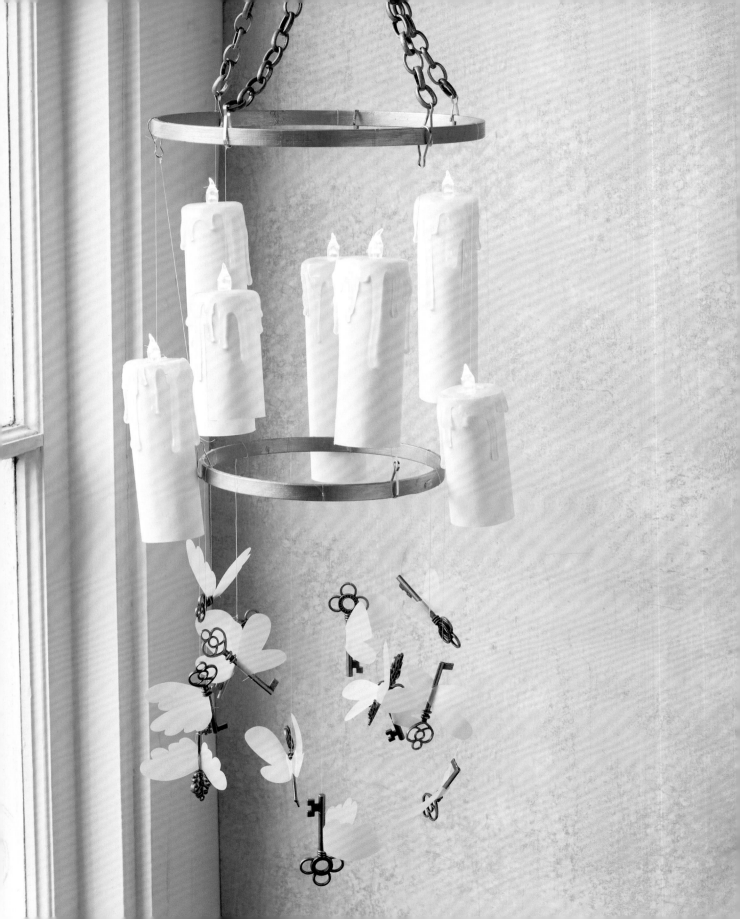

Two-Tiered Magical Chandelier

One of the most wonderful things about the Great Hall at Hogwarts is the floating candles. They seem like such a simple piece of magical décor, but are visually so stunning! Did you know that the floating candles are also enchanted to keep the rain and snow from falling in the Great Hall?

This Two-Tiered Magical Chandelier has handmade floating candles that really light up to add a little bit of that Great Hall magic and give off a warm and cozy ambiance to your home as the days get darker. To go along with the theme of enchanted airborne objects, this chandelier has a second tier of winged keys (don't worry, they won't attack you). Did you know that the winged keys trap in *Harry Potter and the Sorcerer's Stone* was Professor Flitwick's creation?

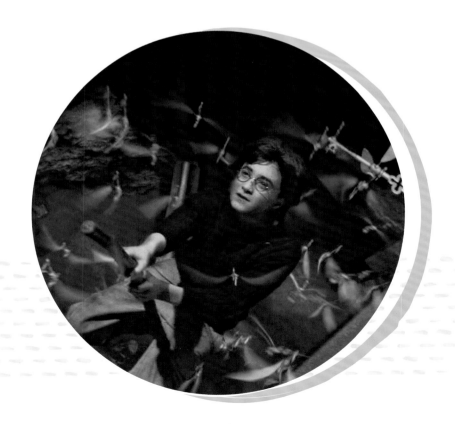

What you'll need

- 6-inch (15.24 cm) wood floral hoop
- 8-inch (20.32 cm) wood floral hoop
- Silver acrylic paint
- 7 remote-operated flickering tea lights
- Hand drill and 1.5mm bit
- 4 sheets white cardstock
- Quick-drying paper adhesive
- Hot glue and glue sticks
- Invisible hanging wire
- Key Wing template, page 92 ⊙
- Pearlescent vellum sheet
- Scissors
- 13 faux vintage keys
- 18-inch (45.72 cm) silver jewelry chain
- 12 lanyard clips
- 1½-inch (3.81 cm) metal S hook

Instructions

1. Paint both wood floral hoops with silver acrylic paint. Be sure to paint all sides with two coats of paint. Make sure that each coat of paint dries completely before adding another. Set aside.

2. Use a hand drill to make a small hole in the "flame" of each tea light.

3. Cut the sheet of white cardstock in half, vertically. Cut each half sheet of paper in a variety of lengths.

4. Apply some quick-drying adhesive to the sides of a tea light and along the side edge of the paper. With the paper standing vertically, wrap one of the papers around the tea light and create a tube. Hold the paper along the tea light with one hand and hold down the edge of the paper with the other while the adhesive sets.

5. Add some hot glue around the top edge of the paper where it lines up with the top of the tea light, letting the glue drip down the sides of the

paper. Add drips all the way around. Stand it up and let the glue cool completely.

6. Repeat steps 3 and 4 for each of the candles.

7. Cut invisible hanging wire for each of the candles. Thread the end of the wire through the hole in the flame and tie a square knot to keep it in place.

8. Tie the other end of the wire to the 8-inch floral hoop. Repeat the threading and tying for all the candles.

9. Space the candles out evenly on the hoop. Add a drop of quick-drying adhesive to the top of the hoop over the wire to keep everything in place.

10. Download or trace the Key Wing template (page 92) and use scissors to cut wings out of vellum for each of the keys.

11. Fold the wings in half and attach them to the keys with quick-drying adhesive. Let the adhesive dry completely before moving onto the next step.

12. Cut varying lengths of invisible wire for each of the keys. Tie one end onto the key, and the other to the 6-inch (15.24 cm) hoop. Be sure to tie the keys on in varying lengths to give the effect of them randomly flying around.

13. Split the jewelry chain into two 9-inch (22.86 cm) pieces. Remove the lobster clasp (if there is one). Attach a lanyard hook to the end of each chain.

14. Attach one chain to the candle hoop with the lanyard hooks on opposite sides of the hoop.

15. Hook the other length of chain to the hoop perpendicular to the first chain and attach the lanyard hooks on opposite sides.

16. When both chains are lifted, they should cross over in a "+" shape. Find the center of both chains and loop the end of an "S" hook through both center chain links.

17. Cut four pieces of hanging wire measuring 10 inches long. Tie the ends of each piece of wire to a lanyard hook. Make sure to keep each piece of wire the same length after tying the hooks on.

18. Attach four of the pieces of wire to the key hoop in a "+" shape, the same way as the chains.

19. Bring the wires straight up from the key level and attach the last four lanyard hooks to the candle level.

20. Hang the S hook from the ceiling and adjust any of the lanyard hooks to balance the chandelier, if necessary.

TIP:

Make rolling a paper tube easier by placing another tea light at the other end of the paper (no adhesive). Remove the bottom tea light once the adhesive has dried.

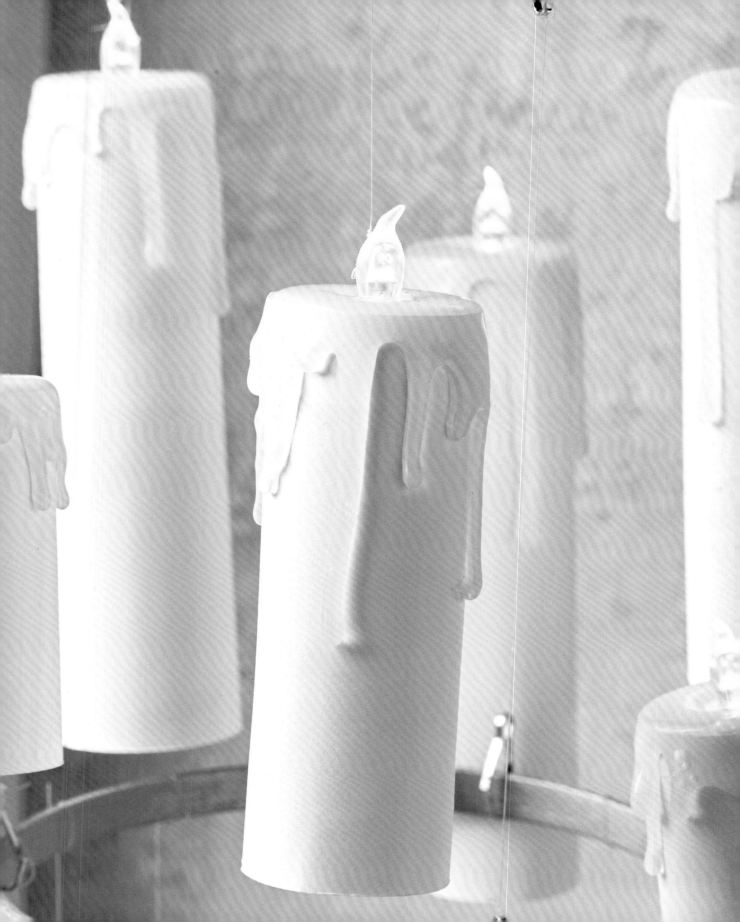

Key Wing Template

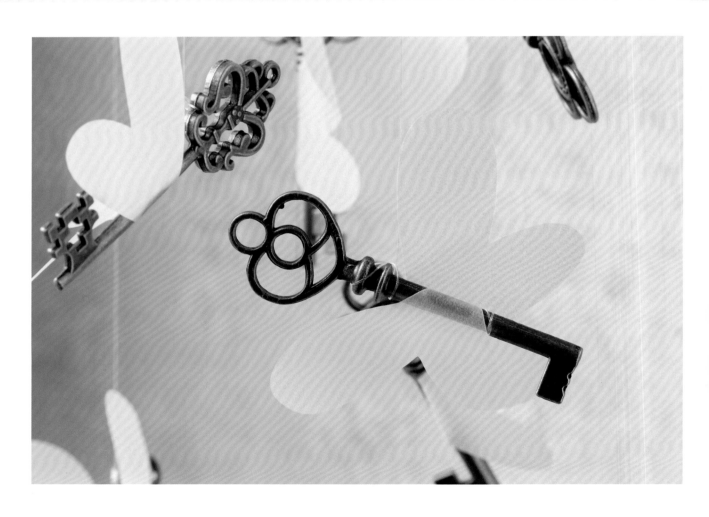

Behind the Magic

In *Harry Potter and the Sorcerer's Stone*, the floating candles in the great hall were actually 350 to 400 real candles suspended by wires that moved up and down. They looked amazing, but during the first days of filming, the heat from the flames burned right through the wires and caused candles to start dropping onto the tables! For safety, all the floating candles were immediately replaced with digitally created ones.

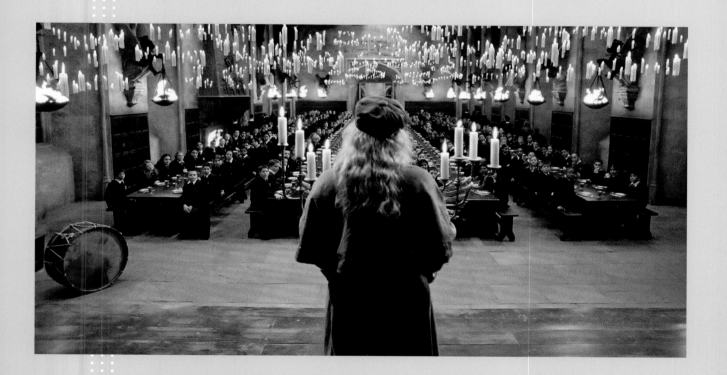

"Happiness can be found, even in the darkest times, if one only remembers to turn on the light."

—Albus Dumbledore, *Harry Potter and the Prisoner of Azkaban*

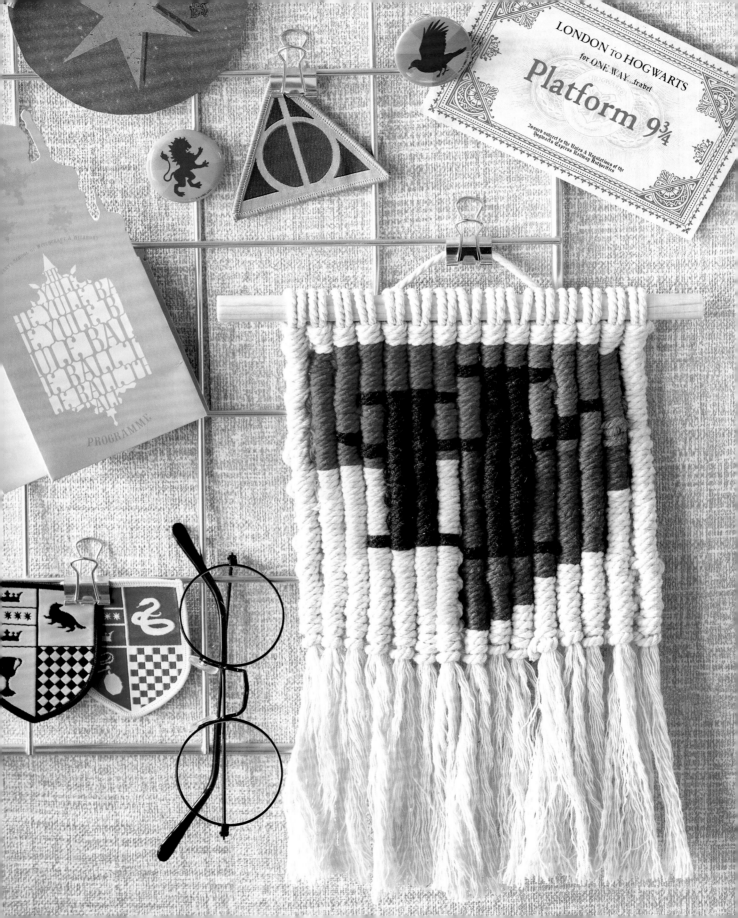

Hogwarts Macramé Wall Hanging Display

Students everywhere enjoy decorating their personal spaces with items to represent their school pride, and Hogwarts students are the same way. After the students are settled in their room when they go back in the fall, they decorate their space with Hogwarts decor.

This Hogwarts crest macramé project is "knot" something to pass up! It's a fun project that could be made at the beginning of term to start the school year off right. It's a statement piece that Hogwarts students everywhere can hang up to display some school spirit!

What you'll need

- Hogwarts Crest Macramé template, page 98 ⬇
- 32 yards (2926 cm) of 3mm macramé cord in natural (or white), black, red, blue, and yellow
- Scissors
- ½-by-8-inch (1.27-by-20.32 cm) wood dowel
- Packaging tape
- Fabric adhesive (optional)

Instructions

1. Copy or bookmark the Hogwarts Crest Macramé template (page 98) to create the pattern using macramé.

2. Cut 15 lengths of natural macramé cord measuring 40 inches (101.6 cm) each.

3. Attach the cords to the dowel using a *Lark's Head Knot* on page 97. Each pair of knotted cords are going to be called the "filler cords."

4. The "working cords" are going to be how color is added to the wall hanging. Each of these cords needs to be cut to 120 inches (304.8 cm). Cut 4 to 5 lengths of natural macramé cords and 2 to 3 lengths each of the black, red, blue, green, and yellow cords.

5. Add some tape to both ends of the dowel and attach it to your workspace. This will keep the dowel in place, making it easier for you to complete the project.

6. Starting from left to right, tie the working cords to the filler cords using *Vertical Double Half Hitch Knots* (see tips below). Each set of knots represents one square on the template pattern, so refer to it often.

7. The first row of knots is an all-natural color cord, so use one of the 120-inch (304.8 cm) lengths of cord as your "working" cord and tie a set

of *Vertical Double Half Hitch Knots* to each pair of filler cords.

8. When you complete the first row, you are going to start the next row of knots. These are tied the same way, but in the opposite direction. When you get to the end of this row, you will switch direction again and keep repeating this pattern until the project is complete.

9. To add a new color, follow step 1 of the *Vertical Double Half Hitch Knots* (see tips below) with the new color cord. Leave the remaining cord of the previous square/color in place. When you need that color again, just bring the cord around the back of the project and tie it into place on the necessary set of filler cords.

10. Follow the template to keep tying rows of knots until the wall hanging is complete.

11. When finished, tuck in any loose cord ends (not the bottom ones) on the back of the wall hanging. If necessary, trim and use fabric adhesive to keep the cord ends in place.

12. Untwist each of the remaining filler cords hanging at the bottom and separate them. Comb through them with your fingers or with an actual comb. Trim the ends so that they are all the same length.

TIP:

If you are a visual learner, you can turn to online video tutorials that will be helpful to learn the *Lark's Head Knot* and the *Vertical Double Half Hitch Knot.*

How to tie a *Lark's Head Knot*:

1. First fold the cord in half.

2. Put the loop at the top behind the dowel.

3. Thread the ends of the rope through the loop, pull down, and tighten.

How to tie a *Vertical Double Half Hitch Knot*:

1. Hold the working cord behind the first set of filler cords. Leave a short end on the left-hand side and hold it in place.

2. Bring the other end around the front of the filler cords and thread the end through the loop.

3. Pull it tight and slide the knot to the top.

4. Repeat the knot a second time to complete the *Vertical Double Half Hitch Knot*.

5. When you are working left to right, keep the loop to the right. When working right to left, switch the loop to the left.

Lark's Head Knot

 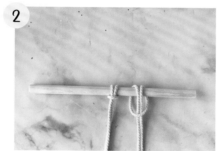 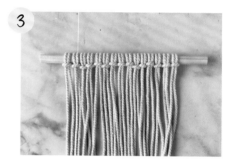

Vertical Double Half Hitch Knot

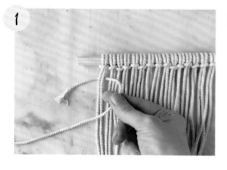 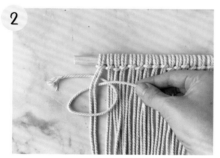 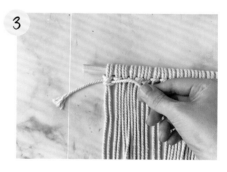

Adding a New Color

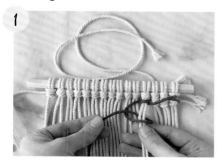 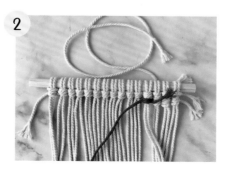

Hogwarts Crest Macramé Template

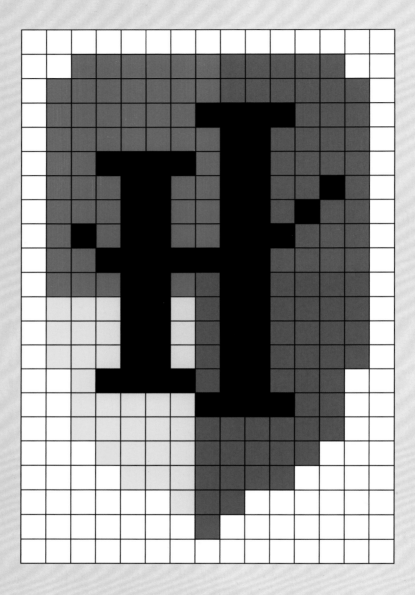

Behind the Magic

Even though the actors who played the Gryffindor students grew through the years, the five-foot, nine-inch long beds did not. When designing the dormitories for the films, all of the furniture was exactly the same, but they made sure that each area reflected the interests of the character. For example, Ron displayed his Chudley Cannon Quidditch posters, and Neville always had lots of books and plants on the bedside table. Each year, the props department created new notices for clubs, lost items, or homework helpers that were posted on an announcement board.

"I'm not going home. Not really."

—Harry Potter, *Harry Potter and the Sorcerer's Stone*

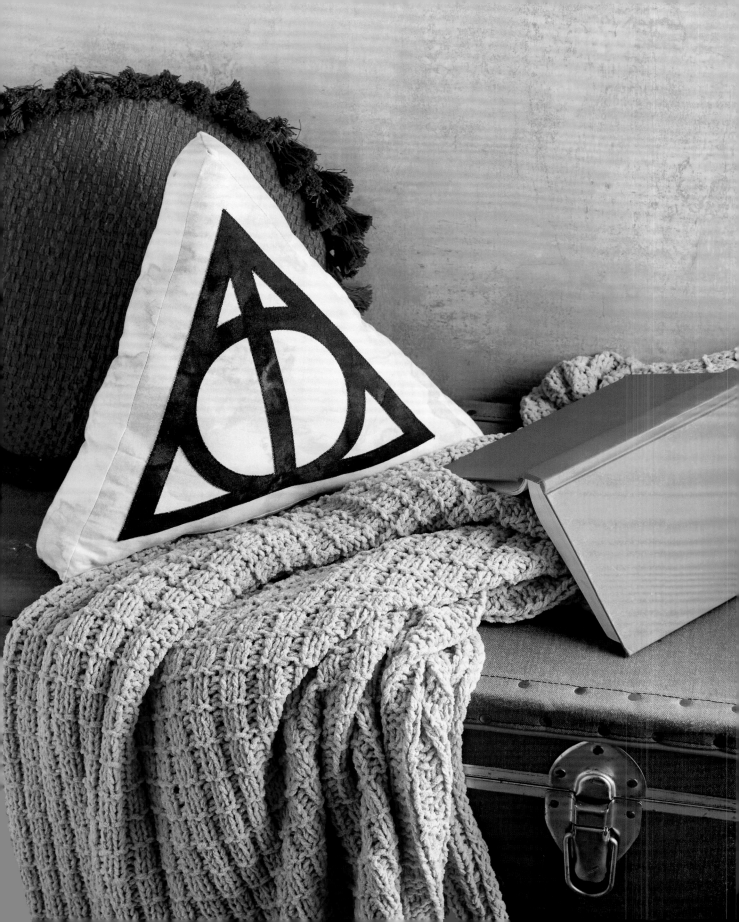

Deathly Hallows Pillow

The Deathly Hallows come from a wizarding story, "The Tale of the Three Brothers," found in the book *Tales of Beedle the Bard*. In the story, three wizard brothers encounter Death. They make a deal with Death, and each receives a gift: the Elder Wand, the Resurrection Stone, and the Cloak of Invisibility. Soon after receiving their gifts, the brothers with the wand and the stone come to tragic ends. The last brother, however, lives a long and happy life while using the cloak to hide from Death. When he is ready, he greets Death like an old friend. What most wizards don't know is that the three legendary gifts from the story—the Cloak of Invisibility, the Elder Wand, and the Resurrection Stone—are actually genuine items that make up the Deathly Hallows.

In *Harry Potter and the Deathly Hallows — Part 1*, Albus Dumbledore left a copy of *Tales of Beedle the Bard* to Hermione in his will. When visiting Xenophilius Lovegood, Luna Lovegood's father, to ask him about the Deathly Hallows symbol, he had Hermione read "The Tale of the Three Brothers" from her book to Harry and Ron. The theme of trying to cheat Death really resonated with the trio, as they were currently hunting for Voldemort's Horcruxes at the time.

When changing out your summer decor for autumn, consider making a handmade Deathly Hallows Pillow to put on display. Autumn is the best time of year to cuddle up with a soft pillow and read the haunting "Tale of the Three Brothers"!

What you'll need

- 1 fat quarter (50-by-55 cm) white or gray fabric
- Cutting mat and rotary cutter
- 1 fat quarter (50-by-55 cm) of black fabric
- Iron-on double-sided adhesive (sewable)
- Iron
- Deathly Hallows template, page 104 ⊙
- Scissors
- Sewing machine (optional)
- Sewing pins or clips
- Chopstick or fabric turning tool
- 1 pound (453.59 g) pillow stuffing
- Embroidery needle

Instructions

1. Cut two 15-by-15-inch (38.1-by-38.1 cm) squares out of the white or gray fabric using a cutting mat and rotary cutter. You will also need three 3-by-18-inch (7.62-by-45.72 cm) rectangles of this same fabric.

2. Fold the square fabric pieces in half and follow the 60° guideline on the cutting mat to cut the fabric squares into a triangle.

3. Cut the black fabric and the iron-on double-sided adhesive using a cutting mat and rotary cutter to measure 12-by-12 inches (30.48-by-30.48 cm).

4. Place the iron-on double-sided adhesive on the back/wrong side of the black fabric and use an iron to stick it to the fabric. Do not peel away the backing from the adhesive yet.

5. Download or trace the Deathly Hallows template (page 104) onto the black fabric. Use scissors to carefully cut the symbol out of the fabric.

6. Peel the backing away from the adhesive attached to the black fabric. Center the Deathly Hallows symbol on the front of one of the triangles. Use the iron to stick the fabrics together.

7. The adhesive should be strong enough to hold the fabric applique in place, but sewing it looks nicer and finishes the piece. Use a zig-zag stitch with black thread to sew along all the edges of the black fabric.

8. Line the bottom edge of one of the 3-by-18-inch (7.62-by-45.72 cm) rectangles with the bottom edge of the front triangle piece with right sides together. Pin or clip the fabric and sew along the edge with a ¼-inch (0.635 cm) seam allowance.

9. Line up the other two rectangles with the other two edges of the triangle and sew them into place, one strip at a time.

10. Place the other triangle face-down on the front triangle. Sew the opposite edges of the three rectangles to the triangle, the same way as the first triangle piece.

11. Now the only parts left unsewn should be the three corners of the triangle. Line up the ends of the rectangles at the top and mark a line from the top corner of one triangle to the other. Sew across this line to close it up. Trim away any excess fabric, leaving about ¼ inch from the seam.

12. Cut all the corners at an angle, being careful to not cut through the seams. This will help your corners to have a sharper point.

13. Repeat step 11 for one of the other bottom corners of the triangle. Leave the other corner open.

14. Flip the fabric right-side out through the corner opening. Use a chopstick or fabric turning tool to poke the corners out.

15. Grab a handful of pillow stuffing. Tear it apart and fluff it up in your hands and then stuff it into the pillow. For best results, start filling the corners first and work your way out. Keep grabbing handfuls of stuffing and filling up the pillow until you get the desired firmness.

16. When the pillow is filled, close the last corner. Trim away any excess fabric first and then fold the seam allowance inside. Pin the fabric in place and use a needle and thread to sew it closed.

TIP:

It's important to get a "sew-able" adhesive if you plan on sewing the applique down. If it doesn't say sewable on the package, you could potentially ruin your machine if you try to sew over it.

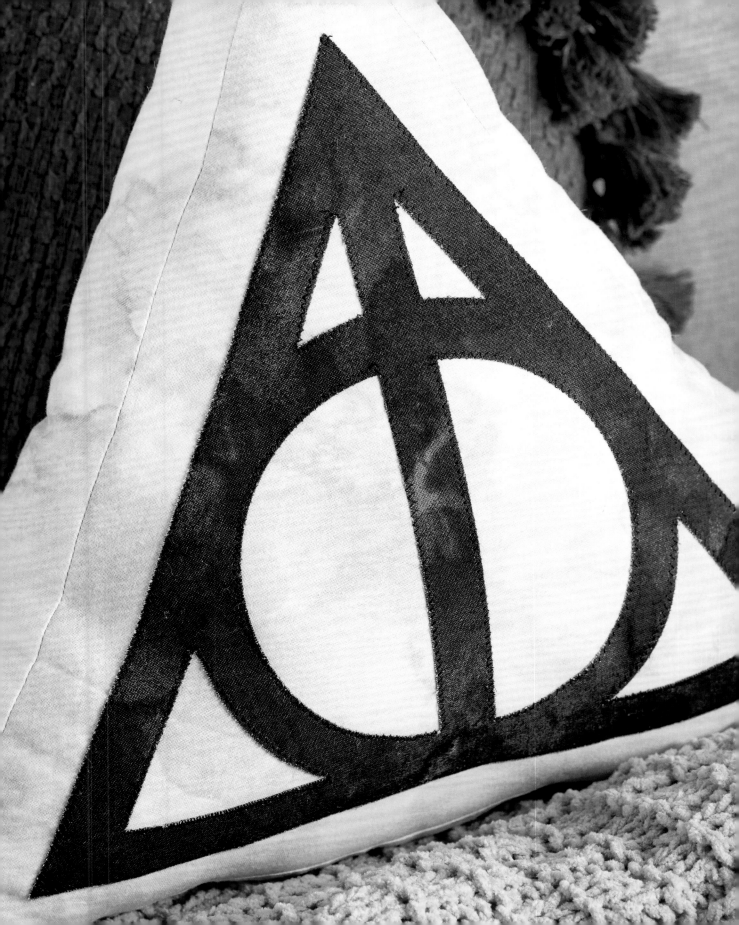

Deathly Hallows Template

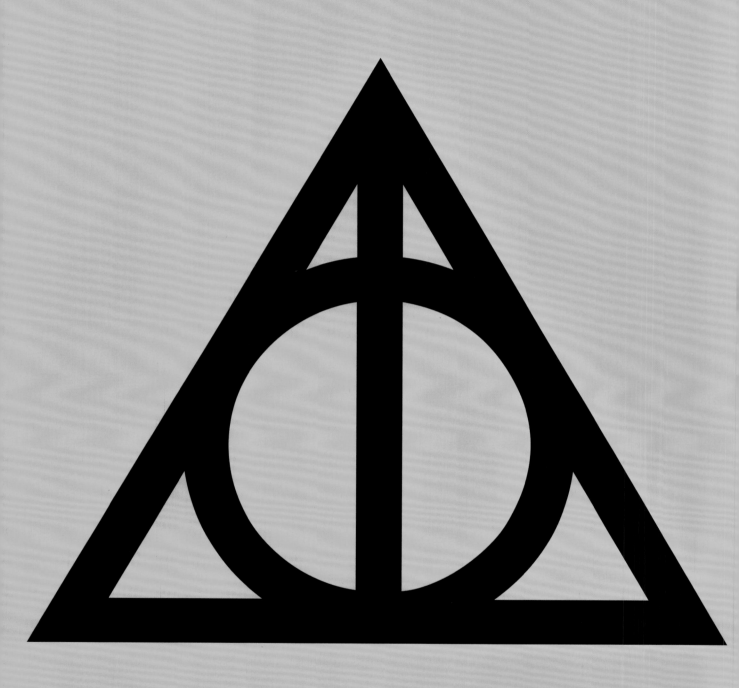

Behind the Magic

Book covers for the films were carefully designed to reflect the period they would have been created in. *Tales of Beedle the Bard* was made to look old and passed down, and the inside is just as detailed. Each book in the film, whether featured or not, was not just a beautifully detailed cover. MinaLima, the creative graphic prop duo for the Harry Potter films, made sure that all of the books had pages designed inside as well. Actors loved being able to actually read books like *A History of Magic*.

"'The Elder Wand,' he said, and he drew a straight vertical line on the parchment. 'The Resurrection Stone,' he said, and he added a circle on top of the line. 'The Cloak of Invisibility,' he finished, enclosing both line and circle in a triangle, to make the symbol that so intrigued Hermione. 'Together,' he said, 'the Deathly Hallows.'"

—Xenophilius Lovegood, *Harry Potter and the Deathly Hallows — Part 1*

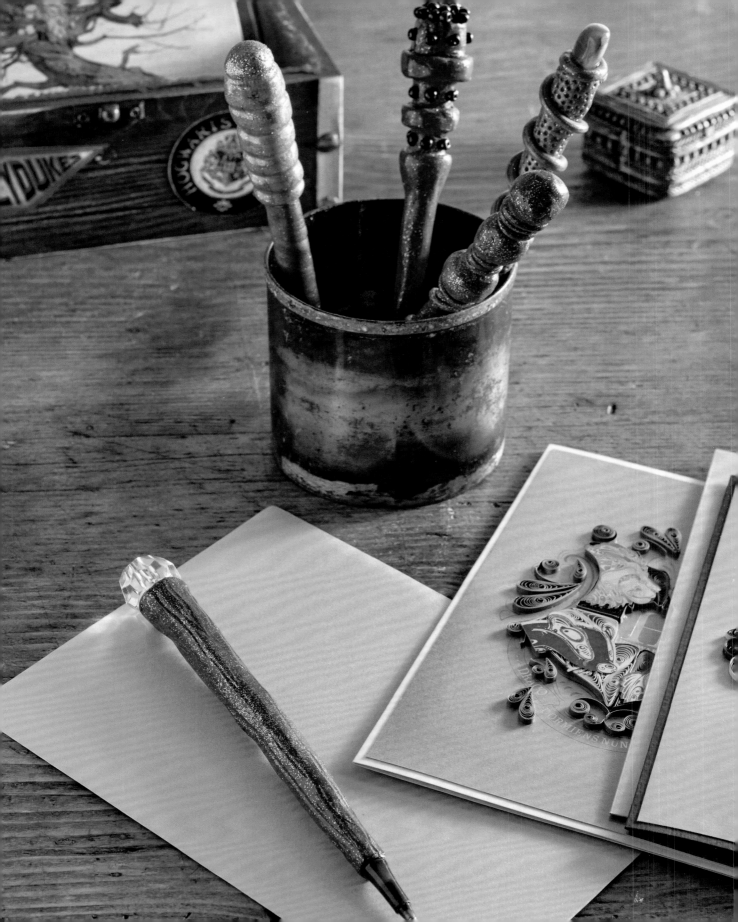

Clay Wand Pens

Wands are a necessity in the wizarding world for casting spells and charms. The amazing thing about wands is that no two are alike. Even if they are made of the same wood or core material, each wand is unique to every wizard.

The iconic scene of Harry getting his wand in *Harry Potter and the Sorcerer's Stone* was a magical moment created with practical effects. By slowing the frame rate from 24 to 120 frames per second, it made the smoke, lights, and wind blowing through Harry's hair appear to be real magic!

It has been said that the wand chooses the wizard, but in this instance, you can create your own custom wand design to write with at school or work! These Clay Wand Pens are a simple and creative way to take your school or office supplies up a notch and will be the talk of the classroom on the first day of school!

What you'll need

- Pens (inexpensive plastic ones work best, but avoid clear plastic pens)
- Polymer clay in browns, metallic browns
- Decorative beads, gems, or rocks
- Glitter, optional
- Clear spray paint or varnish

Instructions

1. Remove the lid, tip, and ink from the pen and set it aside.

2. Take a section of clay and warm it up in your hands. Knead the clay to soften it enough to mold it. If you want a marbled look, add in another color of clay and knead it over multiple times until you get the look you want. If you want a sparkling wand, add in fine glitter, a little at a time, and knead it in until it's evenly distributed.

3. Tear off a small piece of clay and wrap around the pen tube and smooth it out by lightly rubbing a fingertip over it. Keep adding and smoothing clay until the pen is covered. Be sure to not cover the opening where the pen tip fits back in.

4. Because every wand is unique, now is the time to add more clay to the pen to sculpt a creative wand design. Have fun adding textures, creating shapes, and adding color using glitter or other clays!

5. Add beads, gems, and/or rocks for decoration to your wand. You can stick numerous smaller beads right into the clay and decorate the entire wand, or use one larger bead or rock at the end of the handle of the wand.

6. When the wand is complete, place it on a pan or cookie sheet covered with parchment paper or aluminum foil. Bake the pen according to

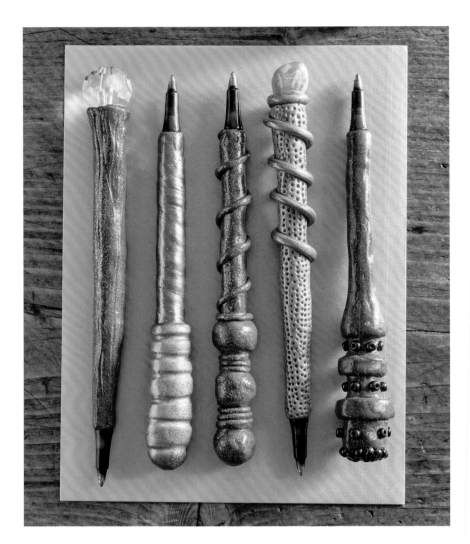

package directions. Let the wand cool completely before handling.

7. Cover the wand with a couple of coats of clear spray paint or apply a clear varnish. This will help your wand last quite a while, and you won't have to make another trip to Ollivanders!

TIPS:

- Before starting the project, test your pen to make sure it won't melt! Remove the ink and tip from the pen and bake the pen tube at 275° F (135° C) for 10 minutes. If it doesn't warp or melt, you are good to go!

- Polymer clay is not food-safe, so I would recommend keeping a separate baking pan for crafting use only.

Behind the Magic

In the Harry Potter films, each wand was designed and created specifically with its fictional owner in mind, which emphasizes the fact that no two wands are alike. Harry's wand design was simple, and actually evolved over the first few films. Voldemort's wand, however, was detailed and appeared to be made of bone. His wand stayed the same after the first design.

Prop makers designed Dumbledore's wand for *Harry Potter and the Prisoner of Azkaban*, but it wasn't actually seen on film until *Harry Potter and the Goblet of Fire*. The wand was made of English oak, with nodules running down the length to resemble clusters of elderberries. Made years before knowing what the Elder Wand even was, it turned out that this wand design was totally unique and instantly recognizable, which made it become the legendary Elder Wand seen in *Harry Potter and the Deathly Hallows*!

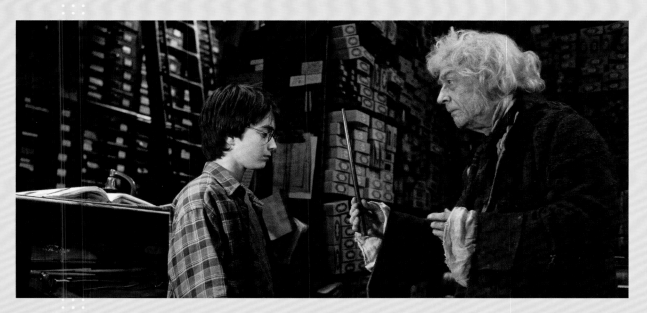

"As I said, the wand chooses the wizard, Mr. Potter. It's not always clear why. But I think it's clear we can expect great things from you. After all, He Who Must Not Be Named did great things."

—Ollivander, *Harry Potter and the Sorcerer's Stone*

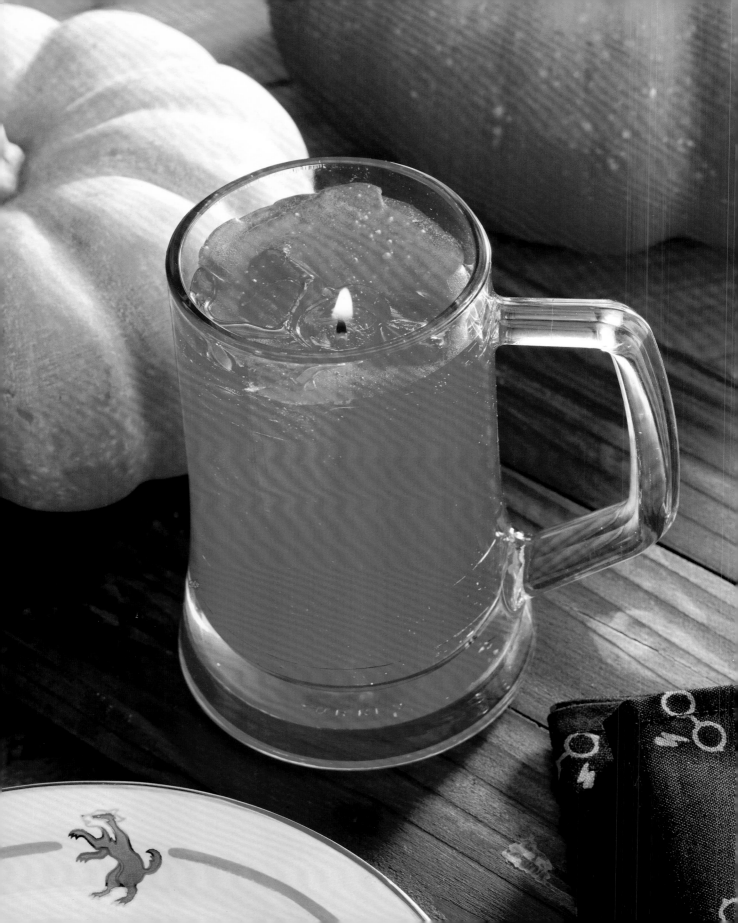

Pumpkin Juice Candles

Pumpkin Juice is one of the most popular drinks in the wizarding world. Typically served on ice, Pumpkin Juice is available to students on the Hogwarts Express and at Hogsmeade. Wizards drink this delightful beverage for any occasion, including meals and special events. During Halloween, pumpkins from Hagrid's hut are used to decorate the Great Hall, and you can guarantee that Pumpkin Juice is served to celebrate!

In *Harry Potter and the Half-Blood Prince*, Harry used the opportunity at breakfast to trick Ron into thinking he poured the Felix Felicis potion into his Pumpkin Juice. Thinking he drank "Liquid Luck," Ron finally got the confidence boost he needed and played a nearly perfect Quidditch match against Slytherin, taking the win for Gryffindor.

Autumn is all about the warm, cozy flavors of fall. When thinking about autumn, pumpkins automatically come to mind, and making a Pumpkin Juice Candle will bring the delightful scent of pumpkin into your home with the look of a refreshing glass of Pumpkin Juice. Like sharing a bottle of Pumpkin Juice with friends, you can also share this candle as a gift.

What you'll need

- Heat-safe glass mug
- 6-inch to 8-inch (15.24 to 20.32 cm) wax candle wick plus wick sticker
- 200 g clear gel wax
- Medium saucepan
- Candle thermometer
- Orange gel food coloring
- Pumpkin candle scent (look for ones specifically for use in gel wax)
- 2 chopsticks
- Tape or 2 rubber bands
- Scissors

Instructions

1. Clean the glass mug out well with soap and water and let it dry completely.

2. Apply the wick sticker to the bottom of the metal tab on the wick. Place the wick in the center of the mug with the metal tab touching the bottom. Use a chopstick or a pencil to press the wick down to secure the adhesive to the mug.

3. Use a knife to cut six ½-inch to 1-inch (1.27 to 2.54 cm) cubes off of the brick of gel wax. These don't have to be perfect since they will become the "ice cubes" in the candle. Set these aside for later.

4. Place the remaining gel wax in a medium saucepan and melt over medium heat. Use a candle thermometer to heat the wax until it reaches 200° F (93.3° C). Maintain this temperature and continually stir the wax until it is completely smooth and melted.

5. Add 3 to 5 drops of orange gel food coloring to the wax and stir until it is completely incorporated. Start with 3 drops, and if it looks like it needs more color, add one additional drop at a time and stir completely before adding another. It can be easy to over-color the gel wax.

6. Add in 20 to 30 drops of candle scent and stir the wax mixture well for two minutes.

7. To hold the wick in place, lay two chopsticks on the top of the mug and sandwich the top of the wick between them. Wrap the ends of the chopsticks with rubber bands or tape to hold the wick tightly.

8. Pour the wax into the mug slowly and carefully until it's about 2 inches below the top. The wax will be very hot, so use caution!

9. After about 2 minutes, carefully place the wax "ice cubes" about halfway into the wax. It's possible that you may not use all of the cubes.

10. Leave the candle to cool at room temperature for at least 4 hours.

11. When the candle is cooled, remove the chopsticks and trim the wick down with scissors or nail clippers to ¼ inch (0.635 cm) above the wax.

TIP:

Enjoy your Pumpkin Juice Candle, but always use caution. Never leave the melting wax or a burning candle unattended. Avoid burning the candle all the way to the bottom. Only burn candles on fireproof surfaces and keep away from flammable objects.

Behind the Magic

Speaking of feasts, did you know that all of the food and drinks served in *Harry Potter and the Sorcerer's Stone* were actually real? Harry Potter film director Chris Columbus didn't want it any other way, because he wanted to ensure that the film's food was just as it was described in the book. The downside to this was that the smell of decaying food became overwhelming after a few days on set. In later films, food was frozen and molds were used to create realistic-looking food.

"You're in for a rough night, Potter. Regrowing bones is nasty business. Well, what did you expect, Pumpkin Juice?"

—Madam Pomfrey, *Harry Potter and the Chamber of Secrets*

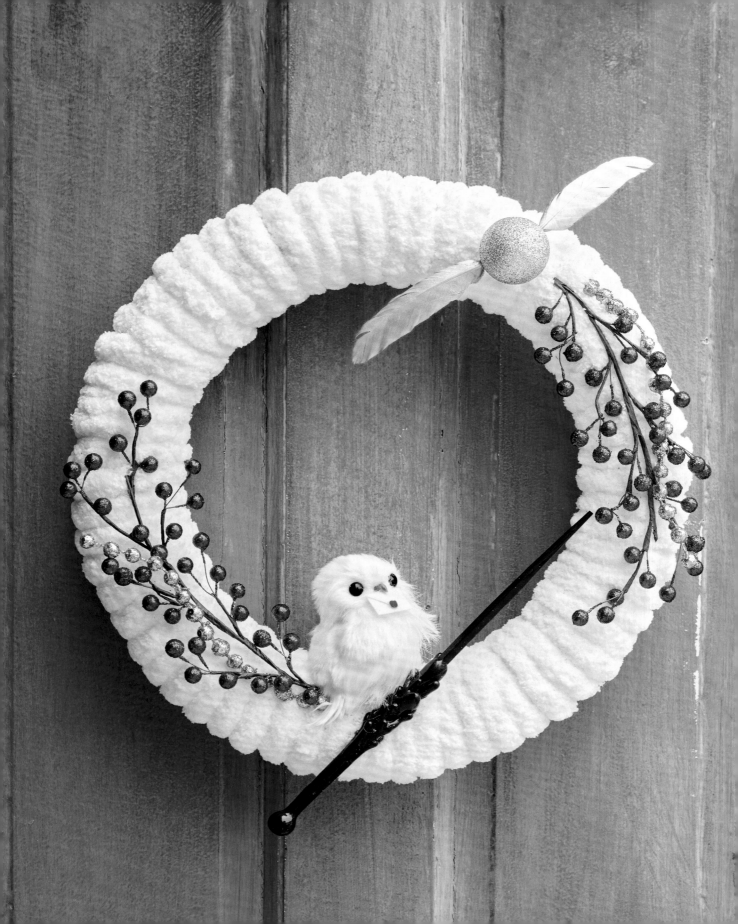

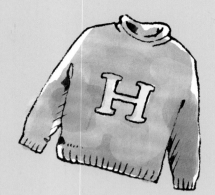

Chapter 4

· · · · · · · · · · · · · · · · · ·

Winter

"Sit down everyone, sit down.
That's it, now present time."

Mrs. Weasley, *Harry Potter and the Order of the Phoenix*

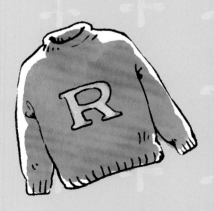

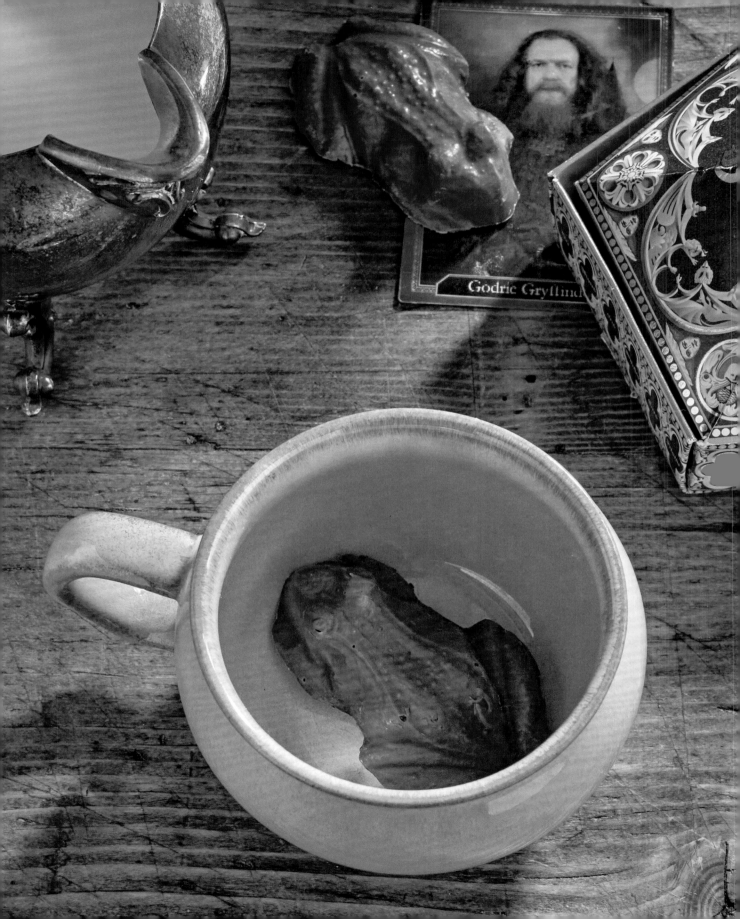

Godric Gryffindor

Chocolate Frog Cocoa Bombs

In the films, wizards of all ages love Chocolate Frogs! They are a popular chocolate treat in the shape of a frog and each one comes with a collectible card featuring a famous wizard. It's said that the Chocolate Frogs are made with 70 percent croakoa (croak + cocoa), a magical ingredient that makes the Chocolate Frogs hop around like real frogs! When it comes to wizarding sweets, author J.K. Rowling has said that Chocolate Frogs would be her favorite.

Chocolate Frogs aren't the only enchanted treat you can enjoy in the wizarding world. Acid Pops, Fizzing Whizzbees, and Ice Mice are just a few magical goodies that have surprising effects. The Weasley twins created their own line of sweets to use to get out of class and to use for pranks. Fainting Fancies, Nosebleed Nougats, Puking Pastilles, and Ton-Tongue Toffee are just a few of the tricky treats found at the Weasleys' Wizard Wheezes shop!

Did you know that chocolate, including Chocolate Frogs, are an important thing for wizards to keep on-hand? Dementor attacks can emotionally drain a wizard, and chocolate will help you recover faster! In fact, Professor Lupin shares a bar of chocolate with Harry and explains this to him on the Hogwarts Express after he wakes up from a Dementor attack in *Harry Potter and the Prisoner of Azkaban*.

When winter hits, there's nothing quite like warming up with a mug of hot cocoa. To make this winter a little more magical, you can mix up a batch of Chocolate Frog Cocoa Bombs to cozy up with in the common room! They are a great treat, and would make anyone "hoppy" to receive one as a gift.

What you'll need

- 3 ounces (85 g) milk chocolate melting wafers
- Frog mold (found online)
- 6 ounces (170 g) semisweet chocolate chips
- ⅓ cup (118 ml) cocoa mix (packaged or homemade)

Cocoa Mix:

- 1 cup (237 ml) dry milk powder
- 1 cup (237 ml) powdered sugar
- ½ cup (118 ml) unsweetened cocoa powder

Instructions

Homemade Cocoa Instructions:

1. Add all of the cocoa mix ingredients into a mixing bowl and whisk together until combined.

2. Mix ½ cup (118 ml) of cocoa mix to ½ cup (118 ml) of hot water to make a serving of hot chocolate.

To make the Chocolate Frog Cocoa Bombs:

3. Place the chocolate wafers in a microwave-safe bowl or use a double boiler to melt the chocolate. If using the microwave, heat the chocolate in 30 second increments and stir until the chocolate is completely melted.

4. Use the back of a spoon or a pastry brush to apply a thin, even layer of chocolate to each frog mold cavity. Place in the refrigerator for 10-15 minutes for the chocolate to set.

5. Melt the chocolate chips in a microwave-safe bowl or use a double boiler. If using the microwave, heat the chocolate in 30-second increments, stir, and repeat until the chocolate is completely melted.

6. Pour ⅓ cup of the homemade cocoa mix (or 2 packets of packaged cocoa mix) into the melted chocolate and stir until combined. The mixture will be thick and grainy.

7. Fill the molds up the rest of the way with the chocolate-cocoa mixture. Smooth out the filling by tapping it down gently with your finger.

8. Place the mold into the refrigerator for at least 30 minutes to set.

9. Once cold, carefully pop the chocolate frog cocoa bombs out of the mold.

10. To serve, warm 10 ounces (283 g) of milk in a glass and drop the chocolate frog in. Stir the frog around with a spoon until melted, and add in your favorite hot cocoa toppings.

TIP:

To make white chocolate frog cocoa bombs, use white almond bark, white chocolate chips, and white hot chocolate mix. For peppermint cocoa, add in 1 to 2 drops of peppermint extract.

Behind the Magic

The Chocolate Frog packaging was never mentioned in the Harry Potter books, so prop designer, Ruth Winick, started with a pentagon shape and took inspiration from Hogwarts' Gothic architecture for the box design. The wizards on the trading cards were made to resemble the ornate, gold frames along the Hogwarts staircases, paired with a dark blue sky and stars for a touch of magic.

"These aren't real frogs, are they?"

"No, it's just a spell. Besides, it's the cards you want. Each pack's got a famous witch or wizard. I've about 500, myself."

— Harry and Ron, *Harry Potter and the Sorcerer's Stone*

Hagrid's Treacle Toffee

Rubeus Hagrid, the Keeper of Keys and Grounds of Hogwarts, often cooks for himself and enjoys his style of cooking, even if it doesn't appeal to his guests. Every Christmas, Hagrid has the tradition of making Treacle Fudge to share with the other professors. He was also known to say that this fudge "gets rid o' slugs in a jiffy"!

Treacle is actually a form of molasses, so we used that to make our version of Hagrid's Treacle Toffee. This decadent treat makes a great gift to share with friends during the holidays and is so fun and simple to make!

What you need

MAKES ONE 9-BY-13-INCH PAN
(ABOUT 20 SERVINGS)

- 1¼ cups (296 ml) butter
- 1 cup (237 ml) sugar
- ¼ cup (59 ml) packed dark brown sugar
- ¼ cup (59 ml) water
- 1 tablespoon (15 ml) molasses
- ½ teaspoon (2.5 ml) cinnamon
- 7 ounces (198 g) dark chocolate chips
- 1 cup (237 ml) chopped pecans or walnuts, optional
- Candy thermometer

Instructions

1. Grease a 9-by-13-inch (22.86-by-33.02 cm) baking dish and set aside.

2. In a saucepan, melt the butter on low heat. Add in the sugar, dark brown sugar, water, and molasses, and stir constantly until the sugar dissolves.

3. Turn the heat up to medium and stir the mixture constantly until the temperature on a candy thermometer is 290°F (143°C).

4. Remove the saucepan from the heat and stir in the cinnamon.

5. Immediately pour the mixture into the baking dish.

6. Let the toffee cool for one minute and then sprinkle the chocolate chips on top.

7. Use a rubber spatula to spread the chocolate evenly over the toffee.

8. If you want to add nuts to the toffee, sprinkle them on evenly while the chocolate is still warm.

9. Place the toffee in the refrigerator to harden.

10. Break toffee into pieces and store in an airtight container.

Behind the Magic

To give Hagrid his half-giant appearance, there were two different sets made for his hut in the films. One set was larger and filled with oversized furniture that gave the effect of characters like Harry, Ron, and Hermione to look a "normal" size. The other set was built much smaller, complete with miniature furniture, to make Hagrid look large.

"Anyway, Harry. Got summat fer yeh. 'Fraid
I mighta sat on it at some point, but 'magine
it'll taste all right jus' the same . . ."

—Hagrid, *Harry Potter and the Sorcerer's Stone*

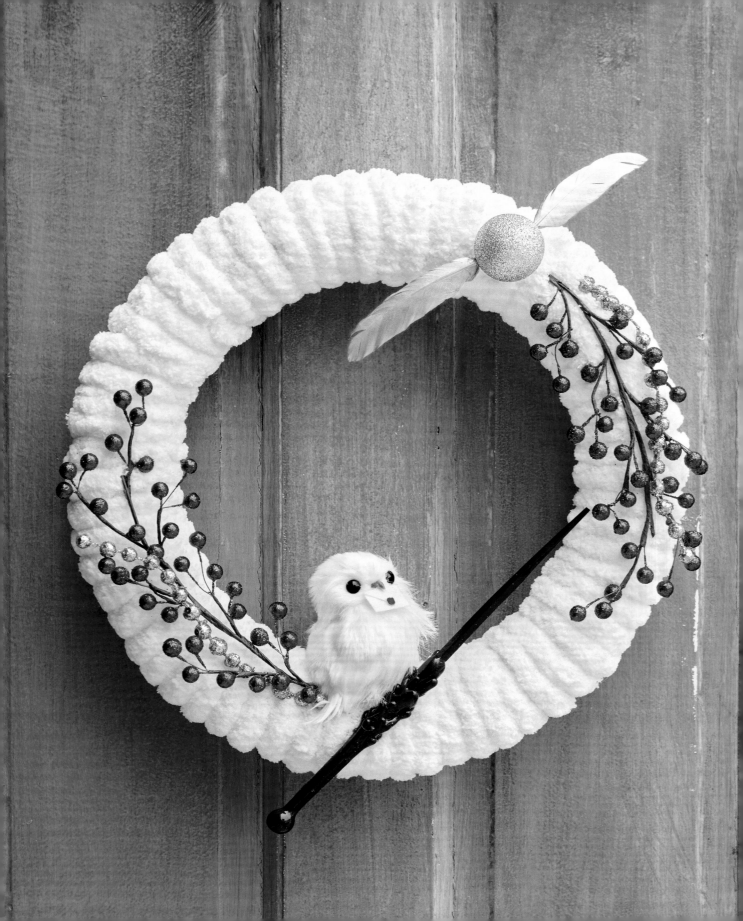

Winter Wizarding Wreath

Hogwarts is enchanting any time of year, but it's especially magical when it's covered in a sparkling blanket of snow. Hogsmeade Village is another snow-filled place to visit to admire the quaint shops and cottages that are dusted with a layer of snow. According to filmmakers, it's winter all year long in Hogsmeade because it's "permanently above the snow line."

Get your home ready for a "Hogwarts in Winter" vibe with this piece of decor! Covered in fluffy white yarn and hints of sparkling red and gold, this wreath features a snowy owl, a handmade wand, and a shimmering golden Snitch!

What you'll need

- 12-inch (30.48 cm) round foam wreath form
- 12 yards (1097.28 cm) chunky white chenille yarn
- Hot glue and glue sticks
- 3.5-inch (8.89 cm) feathered owl figure
- Felt in red and white
- Fabric adhesive
- Chopstick
- 2 glittered berry picks in red and gold
- Two 4-inch (10.16 cm) feathers
- Spray paint or acrylic paint in brown and gold
- 2-inch (5.08 cm) gold glittered plastic ball ornament

Instructions

1. Glue the end of the yarn on the wreath form, preferably at the top or on the back. Wrap the yarn around the form tightly and make sure that you can't see the wreath form between the lines of yarn. Add a drop of glue for every few lines of yarn to keep it in place.

2. When you get to the end of the wreath, trim the yarn to match up with the first end of the yarn that was glued down. If you placed it at the top or on the back, you won't be able to see the seam where the ends meet up. Remove any glue strings, if necessary.

3. Place the feathered owl figure at about "6:00" (see position in the example photograph) on the wreath, sitting toward the front on the curve. Use a generous amount of glue on the bottom of the owl and hold the figure in place until the glue sets.

4. Cut a 1-by-¾-inch (2.54-by-1.905 cm) piece of white felt and a triangle to fit the top half of the rectangle. Line up the top edges of the felt and use fabric adhesive to hold the pieces together. Cut a small, ⅛-inch (0.3175 cm) circle out of the red felt and place it on the bottom corner of the white triangle. You just created a miniature Hogwarts letter! Use hot glue to place the letter right under the owl's beak.

Continued on page 128

Behind the Magic

While the snow may look real in the films, it actually takes quite a bit of magic to make it look that way! One secret is using shredded paper, ground into a snow-like consistency. The great thing about paper is that it's biodegradable, which is great for outdoor filming. Magnesium sulfate, when mixed with water, gives a great effect when sprinkled onto the roofs of model buildings. The best kind of material for filming falling snow, however, is by using shredded plastic, which was only used when filming indoors.

"The Yule Ball is a tradition of the Triwizard Tournament. On the night of Christmas, we and our guests shall gather in the Great Hall, for a night of friendship, and a well-mannered frivolity. It is an occasion for letting our hair down."

—Professor McGonagall, *Harry Potter and the Goblet of Fire*

5. Use hot glue on a chopstick to create a wand. Have fun creating textures and shapes using the glue, but be careful not to burn yourself!

6. Trim the ends of the two glittered red berry picks just below the bottom berries. Carefully bend the picks so they match the curve of the wreath form. Tuck the bottom end of the pick under the yarn just below the owl. Use a drop of glue to hold it in place.

7. Arrange the pick to lay against the wreath and move the berries (if they are on wires) to look how you want. When you like the arrangement, add a drop of glue to the center of the pick and near one of the top berries to hold the pick in place.

8. Repeat steps 6 and 7 for the other pick, but place the bottom of the pick near "1:00" instead. Arrange the top and berries to fit the wreath and glue it into place.

9. Take two strands off of the glittered gold pick and put one next to each of the red berry picks. Use glue to hold the ends in place.

10. Use gold spray paint or acrylic paint to color the front of two feathers. Let the paint dry completely.

11. Use brown spray paint or acrylic paint to cover the chopstick wand. Let the paint dry completely.

12. Hold the gold glittered plastic ball ornament with the top hook facing the back. Poke a hole on each side

of the ornament using a small craft knife. Carefully stick the ends of each feather into the holes in the ornament, and use hot glue to hold them in place. Guess what? You've just made a Snitch!

13. Place the Snitch into place just above the picks on the right-hand side of the wreath, a little above "1:00." Add a generous amount of glue and then place the "top" of the ornament into the glue. Hold it in place until the glue sets. Fluff out the feathers, if necessary.

14. Attach the wand to the wreath at a slight angle under the owl figure. Use a drop of glue wherever it needs a little extra hold.

TIP:

For best results during step 5, work in thin layers and let each one cool before adding another layer. For even coverage and to prevent drips, rotate the chopstick as the glue cools. When the wand is done, set it aside to completely cool.

Moaning Myrtle Bath Bomb

Whenever you step into one of the Hogwarts bathrooms, you will likely find the ghost of Myrtle Warren, otherwise known as Moaning Myrtle. No matter which bathroom she's in, Moaning Myrtle is usually found in a bathroom stall, crying and *moaning* with a gloomy pout on her face. When she wasn't crying, she liked to spy on other students. This actually helped a few times. Like during the Triwizard Tournament, Myrtle admits to Harry (while he's in the bath) that she had been secretly spying on Cedric Diggory in the prefect bathroom while he was in the tub. She watched him open the golden egg under the water to find the clue for the second task, which Myrtle mentioned to Harry to help him.

Hogwarts castle is cold in the winter, especially in the bathrooms where Myrtle likes to hide! Warm up and relax in the bath (but watch for Myrtle, first!) with a cozy bath bomb. It's such a simple craft to make, and the packaging is all about Myrtle!

What you'll need

- Mixing bowl
- Whisk
- 1 cup baking soda
- ½ cup (118 ml) cornstarch
- Black liquid soap dye
- ¼ teaspoon (1.23 ml) soap fragrance
- 1 to 2 teaspoons (5 to 10 ml) almond oil or isopropyl alcohol
- ½ cup (118 ml) citric acid
- Metal bath bomb sphere mold
- 1 clear 11.5-by-5-inch (29.21-by-12.7 cm) cellophane bag
- Small rubber bands
- Black ribbon
- Moaning Myrtle template below ⬇

Instructions

1. In a mixing bowl, whisk the baking soda and cornstarch together.

2. Add in a few drops of the black dye and stir until combined. If it needs more pigment, add in more dye, one drop at a time. The color should be a light gray, similar to Myrtle's ghostly complexion.

3. To make your bath bomb smell better than Myrtle's hiding place, add in the fragrance of your choice.

4. Next, add the almond oil to the mixture and stir until evenly combined.

5. The last ingredient to add is the citric acid. This is what makes the bath bomb "fizz" when it comes in contact with water. When combined, the bath bomb mixture should have the consistency of damp sand.

Moaning Myrtle Template

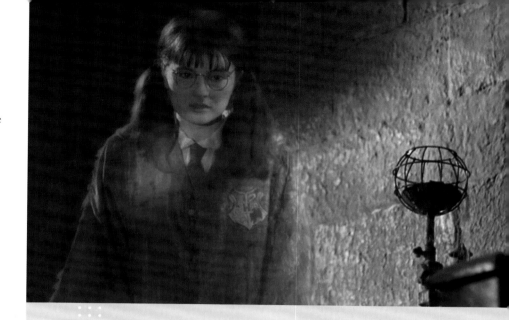

6. Pack the mixture into two halves of a large bath bomb mold. Twist the halves while pressing them together to combine the mold pieces. Remove any excess bath bomb mixture around the seam.

7. Since the bath bomb is damp, it is very fragile. Let it sit for 12 to 24 hours to harden. If you're in a hurry, you can place it in the freezer for 30 minutes.

8. To remove the bath bomb from the mold, gently tap the mold halves with a spoon. You can also put the mold into the freezer for easier demolding.

9. To package the bath bomb to look like Moaning Myrtle, place the bath bomb in the center of a cellophane bag.

10. Use small rubber bands to close the bag on each side of the bath bomb. Tie small pieces of black ribbon into bows on each side to cover the rubber bands and to resemble Myrtle's signature pigtails. Trim the ends of the cellophane bag so that they are even.

11. Lastly, download or trace the template below to add Myrtle's pouty face to the bath bomb.

TIP:
The ingredients in this recipe are safe, even for sensitive skin. For an allergy-friendly bath bomb, you can leave out the fragrance and dye.

Behind the Magic

Though you can't tell by looking at her, Shirley Henderson, the actress who played Myrtle, was 37 years old at the time of filming *Harry Potter and the Chamber of Secrets*, making her one of the oldest actors to play a Hogwarts student! As soon as the director, Chris Columbus, saw her audition, he knew she was meant to be Myrtle.

"I'm Moaning Myrtle! I wouldn't expect you to know me! Who would ever talk about ugly, miserable, moping, Moaning Myrtle?"

—Moaning Myrtle, *Harry Potter and the Chamber of Secrets*

Hogwarts No-Sew House Scarves

Each Hogwarts house has its own colors to represent it. These colors are shown in each house's uniforms, pennants, and so much more. Another way that you can wear your house colors is with a scarf! It's just what you need in those chilly winter months when walking around the castle.

Keep cozy while walking the Hogwarts grounds wearing a handmade scarf made in your specific house colors. The scarf is made using loop yarn, which means you don't have to know how to knit or crochet to make it! You can change the colors to coordinate with any Hogwarts house and will feel so warm and cozy wearing it all winter long.

What you'll need

- 60 yards (5486.4 cm) loop yarn (two colors, 30 yards (2743.2 cm) each)
- Scissors

Instructions

1. Choose which Hogwarts house you want your scarf to represent and get one skein of loop yarn in each color:

 - Gryffindor: red and yellow
 - Ravenclaw: blue and gray
 - Hufflepuff: yellow and black
 - Slytherin: green and gray

2. To make a 6-by-80-inch (15.24-by-203.2 cm) scarf, start by measuring your yarn at 6 inches (15.24 cm) and count how many loops there are at that measurement. For example, my scarf had 10 loops at 6 inches.

3. Lay the yarn down on a flat surface with the end of the yarn on the right and the loops facing up.

4. Keep your finger on the last loop of your line, and fold the next line of yarn over to lay above the first line of yarn. Count out the same number of loops, and make sure the loops are facing up and aligned with the bottom line of yarn.

5. Starting at the left where the fold in the yarn is, take the first loop from the top layer and insert it from behind and pull it through the loop right below.

6. Move on to the next loop, working left to right, and pull the top loops through the center of the bottom loops until you complete the row.

7. Once the row is complete, fold the yarn over and count out the loops again. Repeat steps 4 through 6 until you have created four completely looped lines.

8. To add the next color, carefully snip the bottom seam of the next loop of the color you are currently working

with. This will make the "loop" turn into a straight piece of yarn. Cut where the center of the loop would've been to separate the scarf from the skein. On the next color of yarn, cut the first loop the same way and then tie the straight ends together. Trim off any excess.

9. Lay the line of new yarn above the line you just finished and bring the loops up through the back just like before. When the first couple of lines are done, you can weave the knotted yarn into the scarf to hide it.

10. Make another four lines of the other color of yarn and then switch it out for the first color. Repeat the entire process until you have made 20 sections total.

11. To finish the scarf, trim the yarn right next to the last loop. Start at the right end of the top edge and pull the loop to the left through the one on the right. Loop them all together, and then tuck the last loop into the scarf so that it doesn't pop out and come undone.

Loop Yarn Technique

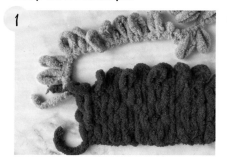
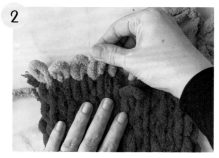
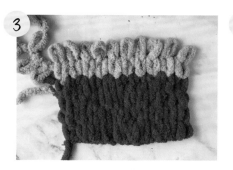
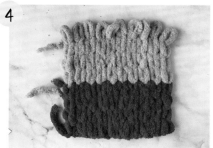

Behind the Magic

The first Hogwarts uniform designs were a white shirt and a house tie, with gray flannel trousers for the boys and gray flannel pleated skirts for the girls. Sometimes they would wear a sweater vest or a sweater with their house colors on it. The first year's uniforms started out with a black tie, but was changed for one with the Hogwarts symbol on it.

The student robe designs were based on traditional academic gowns, but with wizard sleeves. Daniel Radcliffe described the robes as being so comfortable that they felt like pajamas, but admitted that the fires lit in the fireplaces made it too hot to wear them in the Great Hall.

Costuming the children in the films was a huge feat. For every one-character costume, five more costumes were needed for stunt doubles. For Harry Potter alone, sometimes he would have up to twenty-five costumes between him and all of those who worked at being him. That's a lot of wizard-wear!

"Do either of you know what house you'll be in? I'm hoping for Gryffindor—I hear Dumbledore himself was in it— but I think I might just die if they put me in Slytherin. That was You-Know-Who's house."

—Hermione Granger, *Harry Potter and the Sorcerer's Stone*

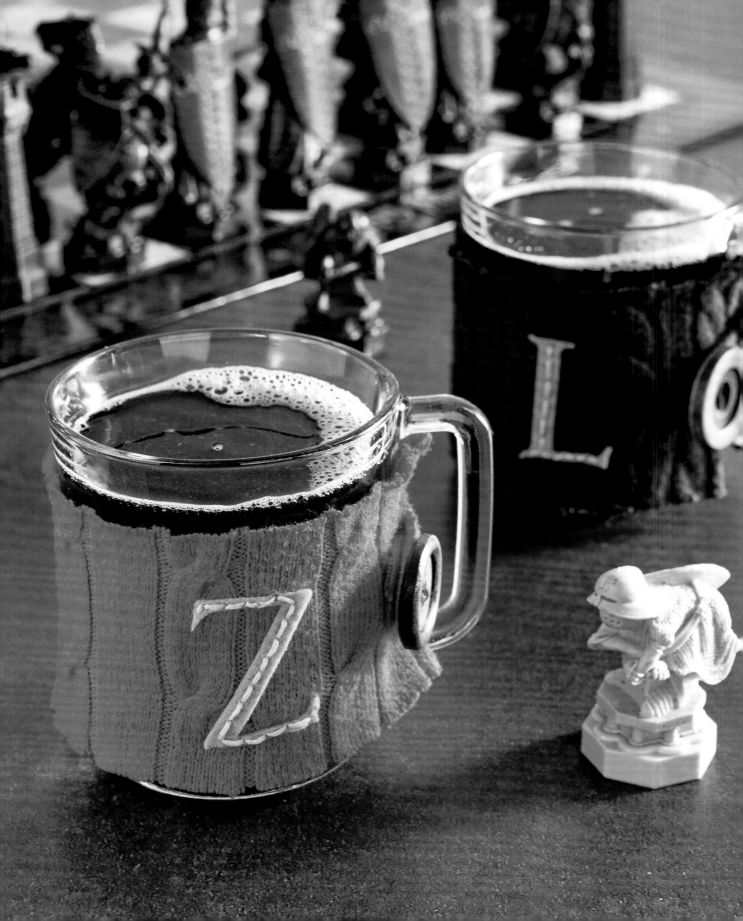

Weasley Sweater Cup Cozy

Every Christmas, Mrs. Weasley knits everyone, including Harry, a sweater with their first initials on it. Harry never received gifts on Christmas from the Dursleys, so his reaction to receiving any gifts at all on Christmas morning at Hogwarts is heartwarming in the films. It was one of the first times in the films that Harry felt what it was like to be part of a family.

This winter, dress up your favorite mug in Weasley style with a Weasley Sweater Cup Cozy to keep your drink warm! Don't forget to add your initial! Even if you don't knit, this will be the easiest sweater you will ever make.

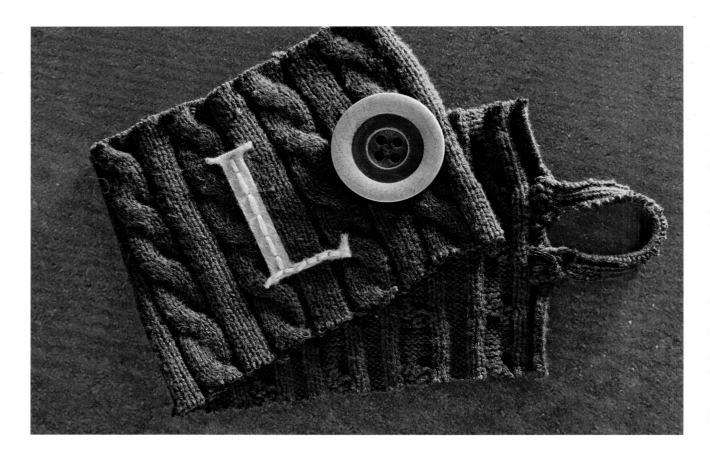

What you need

- Knit sweater, new or old
- Measuring tape
- Scissors
- Matching embroidery thread and needle
- Wooden button
- Yellow felt
- Yellow embroidery thread

Instructions

1. Find a knit sweater that has a cable knit pattern to it. Any color or size will work!

2. Measure the width of the sleeve. If it is 4 inches (10.16 cm) or wider, cut a section that measures 3 inches (7.62 cm) long to make a loop measuring about 3-by-4 inches (7.62-by-10.16 cm) folded. Carefully cut the loop at the seam in the sleeve to make a rectangle measuring about 3-by-8 inches (7.62-by-20.32 cm).

3. If the sleeve is smaller, cut a rectangle measuring 3-by-8 inches (7.62-by-20.32 cm) from the body of the sweater instead.

4. If your sweater starts to fray, do a blanket stitch all the way around the rectangle using embroidery thread (that matches the color of the sweater) and a needle.

5. Cut a small strip from the hem of the sleeve or bottom of the sweater measuring about ¼ inch-by-3 inches (0.635-by-7.62 cm). Attach the ends of this small strip to one of the short ends of the rectangle, making a loop.

6. On the opposite end of the rectangle, sew a wooden button about an inch away from the edge.

7. Draw out your initial measuring about 2½ inches (6.35 cm) on yellow felt and carefully cut it out.

8. Place the initial on the rectangle, about an inch away from the button, and stitch it into place with yellow embroidery thread and a needle.

9. Wrap the sweater cozy around a mug with the ends fitting through the mug handle. Pull the loop over the button to keep the cozy in place.

TIP:

Don't have a knit sweater on hand? Check out your local thrift store for one to repurpose.

Behind the Magic

The Burrow was probably chilly, and Mrs. Weasley loved weaving and knitting, so clothing in the films were made with a wooly/crochet feeling. There were multiple knit sweaters, scarves, hats, and blankets that were purposefully made "imperfect" for the films to give the items a handmade look. Costuming Mrs. Weasley for *Harry Potter and the Chamber of Secrets* took eight to ten weeks. They found fabric that was then crocheted on the edges. Mr. Weasley's clothes were a "woolen-tweed adventure," being mostly old wools, tweeds, and corduroy.

"Happy Christmas, Ron. What are you wearing?"

"Oh, my mum made it. Looks like you've got one, too!"

"I've got presents?"

—Harry and Ron, *Harry Potter and the Sorcerer's Stone*

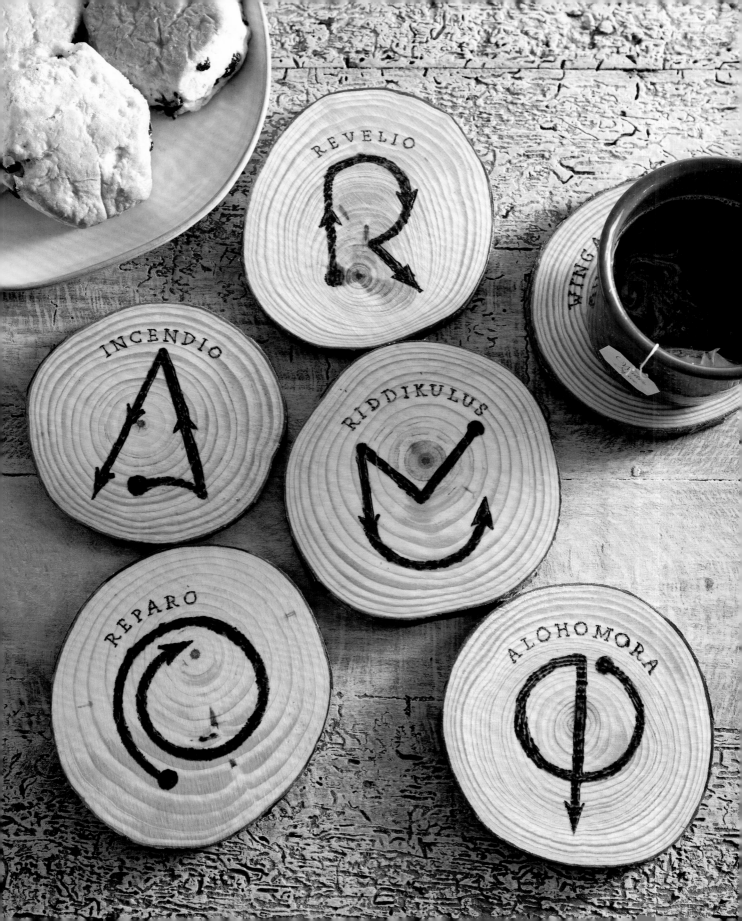

Wood-Burned Spell Coasters

The wizarding world is all about using magic, which means learning to master all the spells! It's important enough that children with magical capabilities attend Hogwarts School of Witchcraft and Wizardry at age 11 to learn all there is to know about their world.

For this set of coasters, six spells and charms were chosen from the films: *Wingardium Leviosa* (to levitate objects), *Reparo* (to repair an object), *Revelio* (to reveal concealed objects), *Alohomora* (to unlock objects), *Riddikulus* (to banish a Boggart), and *Incendio* (fire-making spell).

The cozy, snow-capped Three Broomsticks Inn would likely have sets of wood-slice coasters like these on their tables to match the rustic decor.

Grab a warm winter drink to place on your wood-burned spell coasters to create a cozy environment in your home!

What you'll need

- Six 4-inch (10.16 cm) unfinished wood slices
- Sandpaper
- Spell Coaster template, pages 146–147 ⊙
- Scissors
- Pencil
- Tape
- Wood-burning tool
- Clear spray paint or varnish

Instructions

1. Sand the wood slices so that the surface is nice and smooth. Be careful not to rub off the bark around the edges.

2. Download or trace the Spell Coaster templates (pages 146–147) onto copy paper. Use scissors to separate the different coaster designs.

3. Turn each of the designs over and scribble with a pencil at an angle to rub a layer of pencil lead all over the backs.

4. Center one coaster template on top of a wood slice and tape it down to hold it in place.

5. Trace over the entire spell design with a pencil, using a good amount of pressure.

6. When you peel the design away, the spell coaster design will have been transferred to the wood like, well, magic! Repeat steps 4 and 5 for each coaster.

7. Use a wood-burning tip that looks most like a pencil. Plug the wood-burning tool in and allow it to heat up for at least 5 minutes. Starting with the spell name, place the tip gently onto the surface of the wood to start burning in the design.

8. Maintain a slow, steady pressure so that the amount of "burn" is consistent. Instead of adding more pressure, go over the design multiple times to get darker burn lines. Too much pressure can damage the tool.

9. When you finish the lettering, turn off the tool and let it cool down completely. Change the tip out to one that is a little larger and rounded. Plug the wood-burning tool in and allow it to heat up for at least 5 minutes.

10. Using the same slow, steady pressure, burn the spell action design onto the coaster. Go over it repeatedly to make the burns darker.

11. Repeat steps 7 through 10 to complete all the coasters. Use the pencil eraser to remove any remnants of pencil lead left behind.

12. Cover the surfaces of the coasters with clear spray paint or apply varnish. You may need to apply a few coats for full coverage.

TIP:

Test out the wood-burning tool with the different tips before starting the coaster project to get a feel for how the tool works. The wood-burning tool gets very hot. Be sure to work carefully and prep your workspace beforehand so that nothing gets burned accidentally.

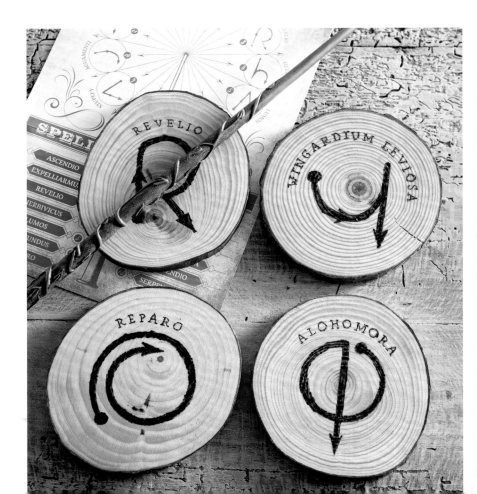

Behind the Magic

When learning spellcasting, you'll find that there is a unique wand movement for each incantation. When the actors were learning to use their wands in the film, they had classes similar to choreography as spellcasting is almost like a dance. They were taught how to hold their wands, how to do different kinds of attacking and defending spells accurately and gracefully.

"*Wingardium Leviosar!*"

"Stop, stop, stop! You're going to take someone's eye out. Besides, you're saying it wrong. It's LeviOsa, not LeviosAR!"

—Ron and Hermione, *Harry Potter and the Sorcerer's Stone*

Spell Coaster Templates

WINGARDIUM LEVIOSA

REPARO

REVELIO

RIDDIKULUS

INCENDIO

ALOHOMORA

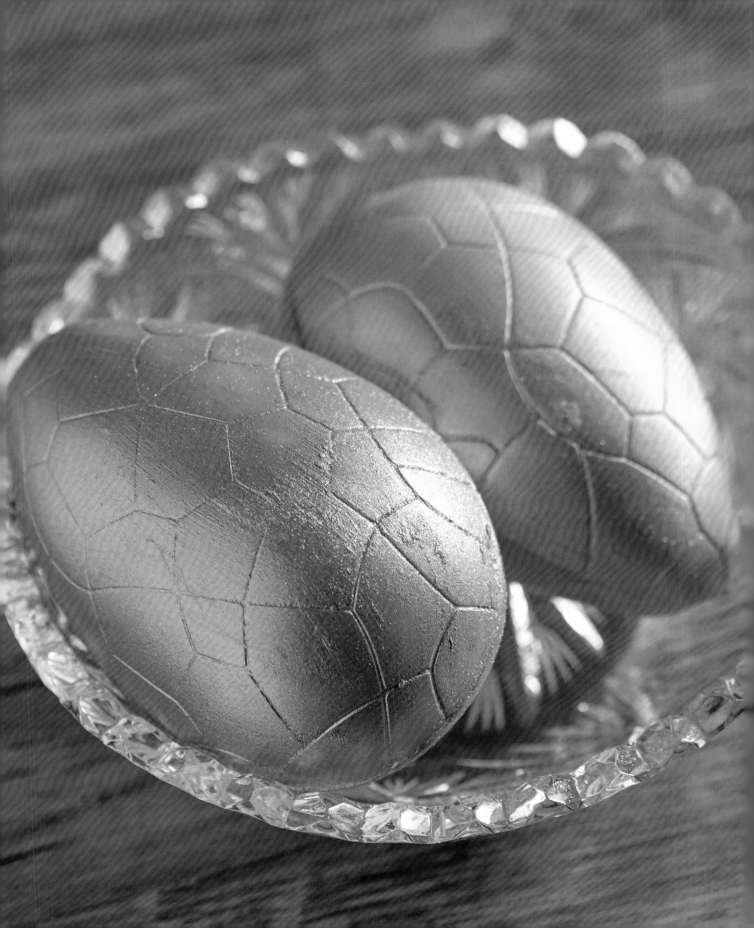

Measurement Conversions

Volume

US	Metric
⅕ teaspoon (tsp)	1 ml
1 teaspoon (tsp)	5 ml
1 tablespoon (tbsp)	15 ml
1 fluid ounce (fl. oz.)	30 ml
⅕ cup	50 ml
¼ cup	60 ml
⅓ cup	80 ml
3.4 fluid ounces (fl. oz.)	100 ml
½ cup	120 ml
⅔ cup	160 ml
¾ cup	180 ml
1 cup	240 ml
1 pint (2 cups)	480 ml
1 quart (4 cups)	.95 liter

Temperatures

Fahrenheit	Celsius
200°	93.3°
212°	100°
250°	120°
275°	135°
300°	150°
325°	163°
350°	177°
400°	205°
425°	218°
450°	232°
475°	246°

Weight

US	Metric
0.5 ounce (oz.)	14 grams (g)
1 ounce (oz.)	28 grams (g)
¼ pound (lb.)	113 grams (g)
⅓ pound (lb.)	151 grams (g)
½ pound (lb.)	227 grams (g)
1 pound (lb.)	454 grams (g)

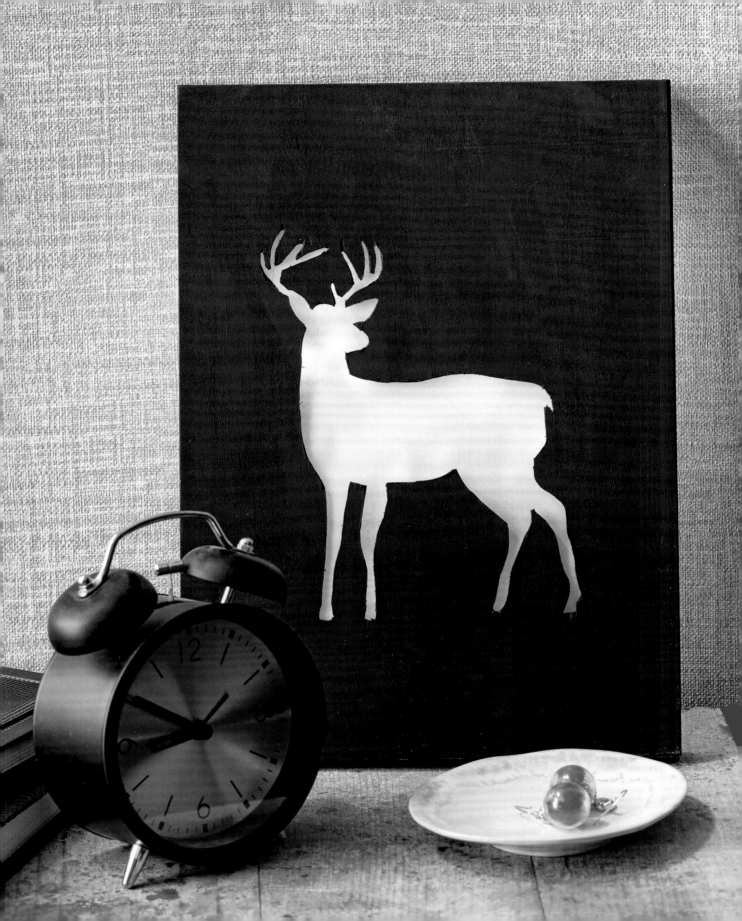

About the Author

Lindsay Gilbert is a muggle-born crafter and glitter enthusiast from Utah. In her free time, she loves traveling, reading (especially the Harry Potter series), and spending time with her family. Lindsay has spent the last decade sharing creative tutorials on her site, Artsy-Fartsy Mama. She's especially fond of making Harry Potter-themed crafts, which inspired the creation of *Harry Potter: Homemade*.

Acknowledgments

"Wingardium Leviosar!"

"Working hard is important. But there is something that matters even more: believing in yourself."

—Harry Potter, *Harry Potter and the Order of the Phoenix*

A huge thank you to my husband and favorite Muggle, Jason, for your never-ending love and support throughout this incredible adventure. To my daughter, Zoey, for always inspiring me to look at life differently and for allowing me to relive the magical world of Harry Potter through your eyes.

Like Ron and Hermione are to Harry, my life is better with Beth and Laura in it. Thank you for believing in me, inspiring me, and being there to cheer me on. Butterbeers are on me!

To Sammy Holland and the Insight Editions team, thank you for this unbelievable opportunity and for all of your hard work to make this dream a reality. I wouldn't be here without you.

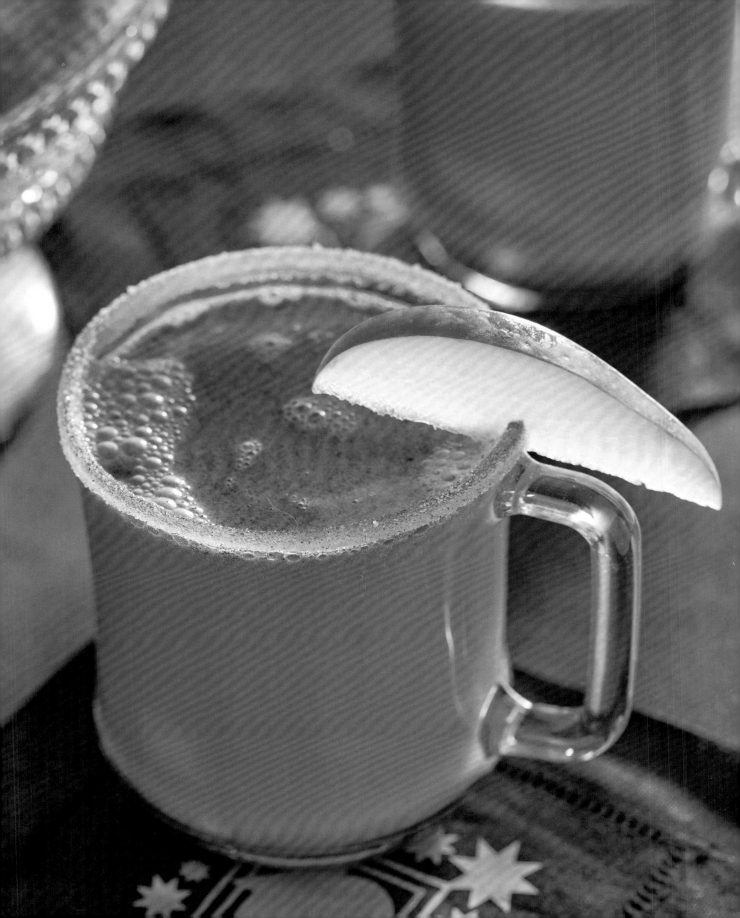